C000165671

LIVERPOOL AT WORK

PEOPLE AND INDUSTRIES THROUGH THE YEARS

KEN PYE FRSA

*To Eric
with best wishes
Ken Pye*

AMBERLEY

ACKNOWLEDGEMENTS

The history of how the people of Liverpool grew with their town into one of the world's powerhouses has been a fascinating one to research and write, and I sincerely hope that you will find it just as fascinating to read.

As with all my books I am most grateful for the help and assistance so freely and generously given by many people and organisations. In particular though, I would like to acknowledge a debt of gratitude to the librarians at the Liverpool Athenaeum, and the staff at Liverpool Central Libraries and City Archive.

First published 2017

Amberley Publishing
The Hill, Stroud
Gloucestershire, GL5 4EP

www.amberley-books.com

Copyright © Ken Pye, 2017

The right of Ken Pye to be identified as the Author of this work has been asserted in accordance with the Copyright, Designs and Patents Act 1988.

ISBN 978 1 4456 7322 6 (print)
ISBN 978 1 4456 7323 3 (ebook)

British Library Cataloguing in Publication Data. A catalogue record for this book is available from the British Library.

Origination by Amberley Publishing.
Printed in the UK.

CONTENTS

INTRODUCTION

Two statues dominate different ends of the city centre of Liverpool. These are both female, which reflects the largely matriarchal nature of the port city's society. This is because the women stayed at home to run family and community (and to keep them as well fed and healthy as their mixed fortunes allowed) while their husbands and childrens' fathers were away at sea, often for years. One statue sits on the dome of Liverpool Town Hall, in what was the original, medieval heart of the city. She is the Roman Goddess 'Minerva', the equivalent of the Greek 'Athena', and she is the patroness of Liverpool.

Minerva sits in powerful and benevolent guardianship over the city as the Goddess of Wisdom, Warfare, Strength, Science, Magic, Commerce, Medicine, Teaching, Creativity, the Arts and Poetry; and as the inventor of Spinning, Weaving, Numbers and Music. She is therefore a perfect symbol of the multifaceted character and versatility of Liverpool.

Her counterpart sits across the town, above the portico of the Walker Art Gallery on William Brown Street, and is the allegorical statue named *The Spirit of Liverpool*. She is shown as a powerful, regal figure wearing both a crown and a laurel wreath on her head. She sits on a bale of cotton, the commodity that played so important a part in Liverpool's commercial history, and which represents the city's trade and industry. The iconic and traditional symbol of Liverpool, the Liver Bird, sits at her left arm. In her left hand she is holding a propeller from a steamship and in her right hand she holds a trident; both of these objects represent the city's domination of the sea. At her feet 'Liverpool' has an artist's paint palette, a designer's compass, and an architect's setsquare. These show that the arts are just as integral a part of Liverpool's life and success as her industry and commerce.

The creation of the unique Liverpudlian character and psyche began with the founding of the town just over 800 years ago, in 1207. From that time and over the centuries Liverpool has been entirely built on immigration and diversity, with its core communities and their descendants arriving from every continent of the world. People came to Liverpool for a whole range of reasons: to take advantage of new economic opportunities to start a business and make money; to escape from starvation, war, or persecution; to find a wife (or husband) and raise a family; or to simply begin a new life.

It takes a certain character to leave all you know behind, for whatever reason, and start all over again. The qualities of those who have helped build Liverpool over the centuries included energy, strength, tenacity, determination and, above all, self-belief and courage. Also needed were the capacity to work hard alongside total strangers, and a willingness to be part of a

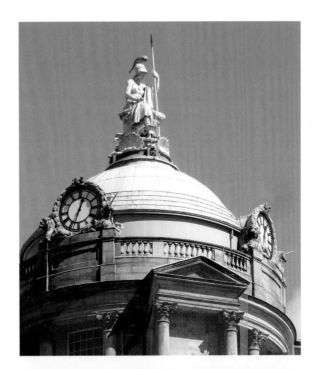

'Minerva' watches over the city from the dome of Liverpool Town Hall. (Discover Liverpool Library)

The 'Spirit of Liverpool' sits atop the Walker Art Gallery. (Discover Liverpool Library)

growing, self-sufficient community that was determined to let nothing and no one stand in the way of personal and collective success.

These traits created the belligerent independence and passionate sense of personal worth and community that are so particular to the people of the city. Those who have tried to dominate and direct Liverpudlians, whether monarch, baron, military commander, merchant prince, shipowner or captain, dockside foreman, manager or factory boss, have all found that to simply issue an order and expect sheepish compliance does not work. Liverpudlians see themselves as at least the equal of everyone else, and expect to be treated accordingly. This self-perception had significant repercussions in the world of work across Liverpool, and throughout its history.

However, it also means that, treated with respect and managed with genuine leadership, Liverpudlians always were, and remain, hard-working, loyal, and invested in their work and professions. However, without such respect and leadership they will consequently block you at every turn, quite simply because they know that, manifestly, they could do your job much better than you!

In this book I trace the beginnings of the city of Liverpool, from its creation by one of England's most unpleasant monarchs, through its development by the labour and skills of its people, and the imagination and creativity of its entrepreneurs, merchants, and captains of industry.

The history of the working life of Liverpool has been driven by its relationship with the great River Mersey and by its miles of docklands that stretch the full length of its waterfront. However, there is much more that has not only created and consolidated the city, but that carved out its position as the greatest city and port in Britain outside of London, and which identifies it as a European Capital of Culture, a World Heritage Port, and a World Class City.

Space does not allow me to go into every detail of Liverpool's complex maritime, commercial, and industrial heritage, so I have rather chosen to focus an indicative selection of its particular trades and industries. Together these trace the working life of the place and its people.

Liverpool's commercial and social history is one of great success and also one of struggle. Mostly though, it is a story of a proud, determined and often exploited people, who strove to survive, grow and take a lead in the world – and they have done just that.

Ken Pye FRSA
Liverpool, 2017

IN THE BEGINNING...

Liverpool is not listed in William the Conqueror's (c.1028–1087) Domesday Book of 1086. This was the Norman King's great ledger of everything he owned and could tax in his newly subjugated country. However, what was then a tiny, insignificant hamlet of very few people generated insufficient income and had so little value that it was not even worth recording let alone taxing. However, almost all of the villages and townships that then surrounded this fishing community *were* recorded. In most cases these had already been in existence for many centuries, including Kirkdale, Toxteth, Garston, Childwall, Everton, Speke, Woolton, Allerton, Wavertree, Walton and, then the most important township for many miles around, West Derby.

As the new town expanded in later centuries these places would become mere suburbs and inner-city districts, as they were absorbed into what developed into a great conurbation, but Liverpool's beginnings were indeed very humble.

Since the earliest times the original hamlet of 'Leverpul', as it was then known, consisted of no more than one or two narrow pathways plus a few cart tracks. These served the families of fisherfolk and smallholders who then lived in the few cottages that nestled on the banks of the obscure River Mersey. Then, in 1207, King John (1167–1216) was attracted here because of the wide and deep tidal inlet off the river, known as 'The Pool'. This was fed by a broad creek rising in the hills that still look down over the modern city and the River Mersey, and this would provide the King with the sheltered, deep-water anchorage he was looking for.

John intended to invade Ireland, and then Wales, Scotland and the Isle of Man, and the Pool would be a natural harbour for his great fleet of warships. So, on 28 August 1207, the King created the Town and Borough of 'Leverpul', to establish a viable economy to service his ambitions. To achieve this, the warmongering monarch needed to increase the local population to create a dynamic, growing, self-governing community.

Such a centre required services, trades, and crafts, as well as sustainable sources of revenue. To initiate this, John granted Liverpool 'Letters Patent' making it a 'Town and a Borough'. This 'Charter' gave 'Leverpul' exemption from certain tolls and taxes, and, most importantly, created 'Burgages'. These were ownership rights for those who, on the annual payment of one shilling to the King, were granted permission to erect a home in the town and to conduct certain trades. Medieval Liverpool was surrounded by fertile land that would produce livestock and crops to feed the growing population. This meant that the King ensured that each Burgage also included two strips of farming or grazing land, in what were designated the common fields of the town.

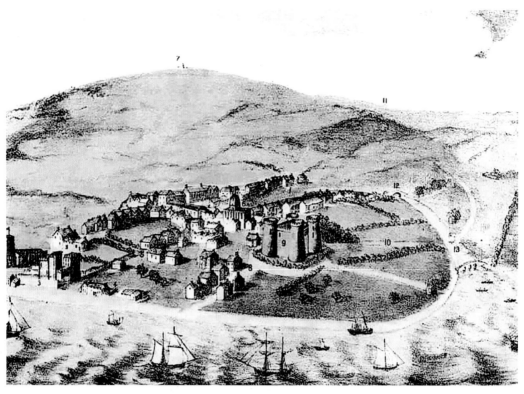

3D map of old Liverpool Town & Pool. (Discover Liverpool Library)

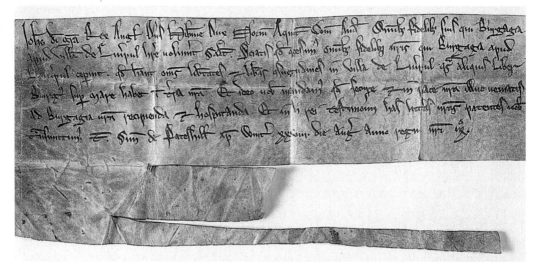

The 'Letters Patent' or 'Charter' of King John creating the Town, Port and Borough of 'Leverpul'. (Courtesy of Liverpool City Record Office)

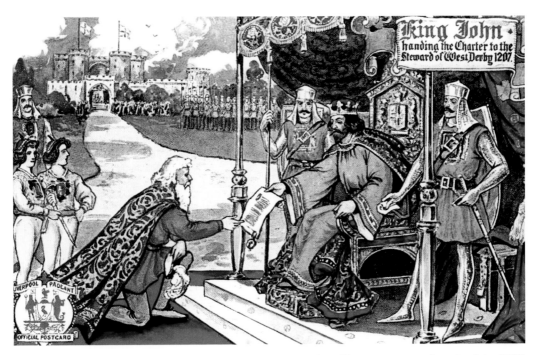

Edwardian postcard showing King John presenting his Charter creating 'Leverpul' in 1207. (Discover Liverpool Library)

Burgages also came with a range of advantageous personal, universal, legal civil liberties, such as the right to gather fuel, as well as exemptions from certain personal taxes, levies and obligations. These opportunities were extremely significant in the highly regulated and class-structured feudal system of medieval England. As a result ambitious entrepreneurs were eager to move here.

There were also vast tracts of forests and woodlands around the new town and its Pool, notably the Stochestede Forest, which is now the modern district of Toxteth. This had been another reason why John had created his new town and port here, because its ranks of sturdy oak trees provided all the timber necessary to construct his invasion fleets, as well as the homes and buildings of Leverpul. The forest stretched southward, from what is now Parliament Street to Aigburth and Otterspool, and eastward, from the banks of the Mersey to the Manor of Esmedune (Smithdown) on the edges of Wavertree.

The forest was home to a variety of game, including boar, deer, rabbits, and game birds, so John claimed this as his own, private Royal Hunting Forest. He surrounded it with a high wall, built lodges to guard its entrances, and installed gamekeepers, wardens, huntsmen, stables and hounds.

Ambitious men of means settled in the new town and so became the first Burgesses of Liverpool. With them they brought their families and their servants, and, in a few cases, their private forces of men-at-arms. For the many ordinary folk who also made Liverpool their new home there was work available; not just servicing the King and the Burgesses as tradespeople, but working on the land as farmers and livestock breeders, and in the surrounding woodlands and forests.

People also laboured on the river, as boatmen, ferrymen and fishermen. They also worked as shipwrights building warships and a growing number of merchant vessels for coastal trade around the shores of Britain and Ireland. The Burgesses became the land and property

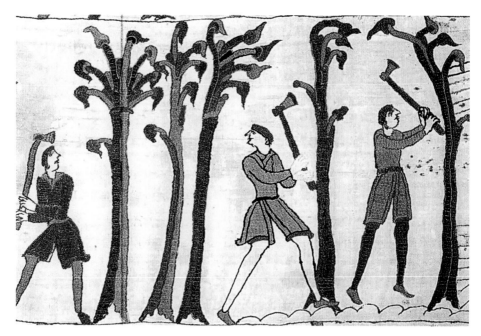

Medieval woodsmen felling trees for shipbuilding. (Discover Liverpool Library)

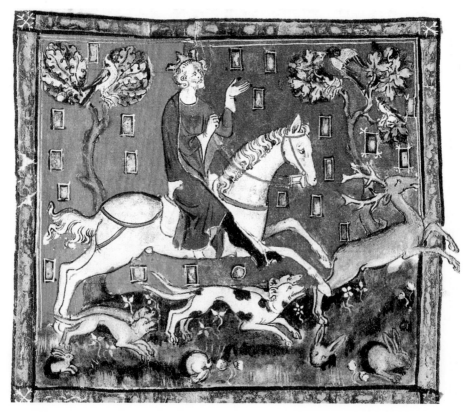

King John hunting. (Discover Liverpool Library)

owners; renting and subletting to generate personal income. They were also merchants and shipowners, making money as Liverpool's maritime and mercantile opportunities developed.

As the new town became established and the population numbers increased, the King instructed that six streets be laid out in an 'H' formation with an extended central cross. These were laid out alongside the tidal creek and Pool. A seventh street, Castle Street, was probably laid out last as a consequence of the building of Liverpool Castle, sometime before 1237.

These original thoroughfares all survived to modern times, although they were widened and their properties rebuilt a number of times over subsequent centuries. The streets are: Whiteacre Street (which became Old Hall Street); Moore Street (which became Tithebarn

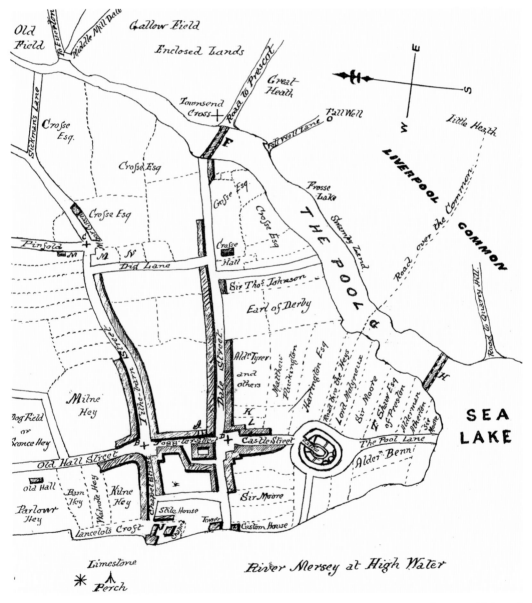

Map showing the layout of the original seven streets of Liverpool. (Discover Liverpool Library)

Street); Juggler Street (which became High Street, and on which the current Town Hall stands); Bonke or Bancke Street (which became Water Street); and Chapel Street, Dale Street and Castle Street, which retain their original names. It was between Castle Street and Juggler Street, in the area in front of the modern Town Hall, that a square came into existence called 'High Cross'. This contained a village cross, the stocks and a pillory. There was also a ducking stool nearby, which was frequently in use.

The area around the town was very hilly, and at its heart was a high promontory of sandstone rock, where Derby Square now stands. This overlooked steep embankments that led down to the river and the Pool. The land was more gently sloping to the north of this broad outcrop, through the large Kirkdale Forest, and also to the east, where Lord Street and Church Street would eventually run. Although much reduced in height over subsequent centuries, the ground level of this part of the town was then so high that it was in this dominant position that the Castle was built.

To encourage the fledgling economy, King John gave permission for a market to be held each week on the shores of the Pool. In medieval times, England was not a 'nation of shopkeepers' but a nation of traders and barterers; indeed, shops were a much later concept. Markets encouraged the exchange of cash as well as goods and, once established, they also attracted additional tradesmen and craftsmen to the new town. In addition to the weekly market, the King gave further permission for an annual fair in Liverpool. This was an extremely large market that brought in people and new businesses from all over the north–west of England.

In 1229, the Burgesses of Liverpool paid ten marks to King John's son, Henry III (1216–1272), to grant another charter. This gave the Burgesses new constitutional, legal and commercial privileges, which remained crucial to the town right up to the outbreak of the English Civil Wars (1642–1651).

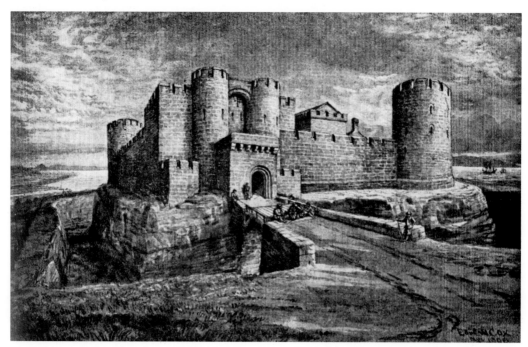

Liverpool Castle. (Discover Liverpool Library)

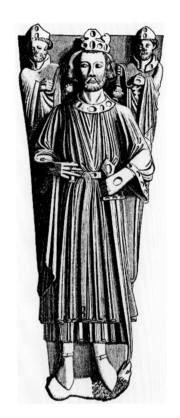

Tomb effigy of King John in Worcester Cathedral. (Discover Liverpool Library)

Within a hundred years of its foundation Liverpool had a resident population of around 800 people. Many of these were engaged in necessary trades, including tanning, blacksmithing, brewing and butchery. There were also large numbers of itinerant merchants and traders, as well as soldiers and sailors, who periodically swelled Liverpool's population. In fact, around 1/5th of the townspeople were sailors.

Milling was an important service because, as well as being a regular source of rental income for the baronial or wealthy families who owned and leased the mills out to tenants, the mills provided flour for the local community's bread. There were at least two mills in Liverpool at this time; a watermill near the Pool and a windmill near the southbound track out of town. Another large windmill was erected at the eastern edge of the town, roughly where the Duke of Wellington's column stands today. Because of its location, this was known as the 'Townsend Mill'.

All of these employment and economic opportunities were extremely significant in the highly regulated structure of Norman England, and so even more people were eager to move into the town. Most initially came from nearby communities but an increasing number were soon arriving from more outlying districts.

However, in comparison to other English towns at that time Liverpool's population growth was quite slow. This was to remain the case throughout the Tudor era, from the reign of King Henry VII (R.1485–1509) to that of Queen Elizabeth I (R.1558–1603) and until the late seventeenth century.

Fishing remained a significant trade, both for home consumption and for limited export, and shipbuilding too continued to be important. Whilst warships were still being built for the military and naval expeditions of successive English monarchs, the mercantile coastal trade now began to increase. Ships designed to safely tackle the complex coastal waters of

13

Townsend Mill. (Courtesy of Liverpool Athenaeum Library)

the British Isles, as well as the often violent Irish Sea, were being built along the Liverpool shoreline with its broad strand of sand and shingle beach.

This took place principally where the Albert Dock complex now stands, at the southern end of the still small town, as well as just at the north of the original town, where Princes Dock now covers the old beachfront. Even so, at this time there was little regular activity on the river, apart from the fishing boats and coastal trading craft, except when troops were being shipped out to war.

By the beginning of the seventeenth century, the permanent population of the town had risen to around 2,000 people. These were mostly living in cottages constructed principally from wood and bricks, and with clay or wattle-and-daub walls. Now though, Liverpool was steadily expanding its inland trade, and so the number of packhorse and cart tracks out of town began to increase to meet demand for trade with the surrounding towns and villages.

It was from this time that the town first began to really use its Pool harbour as a commercial rather than as a military port. Liverpool was now fast becoming a major hub for maritime

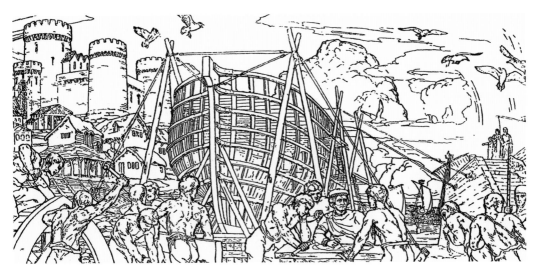

Early shipbuilding on the shores of the Mersey in the shadow of the town's great castle. (Discover Liverpool Library)

trade in the north–west of England and was taking trade away from nearby Chester. This was because the River Dee, on which its rival town sat, had begun to silt up. Liverpool was then able to develop seaborne commerce with Wales and the Isle of Man. However, its principal overseas trading partner remained Ireland. It was from that country that hides, skins and cotton yarn were imported to be processed and sold in the town.

Liverpool now began to export items such as cloth, leather goods and knives, as well as raw materials, such as coal. The port also increased another important source of local income, the servicing of soldiers and sailors billeted in the town. As this was still a period when Liverpool was a major point of embarkation for military campaigns, to Ireland and elsewhere, these temporary residents had money burning holes in their pockets, which they were only too happy to spend in the local taverns and on the local wenches.

As the need for able-bodied and experienced sailors grew, with the number of merchant vessels that were now sailing in and out of the Pool harbour, crewing merchant vessels soon became a dominant source of work.

Other trades that played a role in Liverpool's economy at that time, as well as those associated with the provision of food, clothing and house building, were blacksmithing, cart building and wheel making. Between 1379 and 1600, many new, specialised trades were listed in the official records of the time, The Town Books. These include plasterers, masons, mercers, glovers, slaters, thatchers, archers, panmakers, ropemakers, glaziers, and coopers.

From the sixteenth century, seafaring was overtaking all other trades in the numbers of men employed. Ships were now carrying large cargoes of goods and commodities in and out of the port, to an increasing number of foreign destinations. This was particularly true with the discovery and exploitation of the Americas, and as the continent of Africa was being explored and the fledgling British Empire came into being.

The port was now establishing itself as an important part of the national economy, especially in the moving, storing, handling and transportation of raw materials, manufactured goods and of people. This kind of work requires only minimal skill; mainly brute strength and endurance. As we shall see, this is why Liverpool was to remain, until the twentieth century, largely a labouring and low-skills-based town.

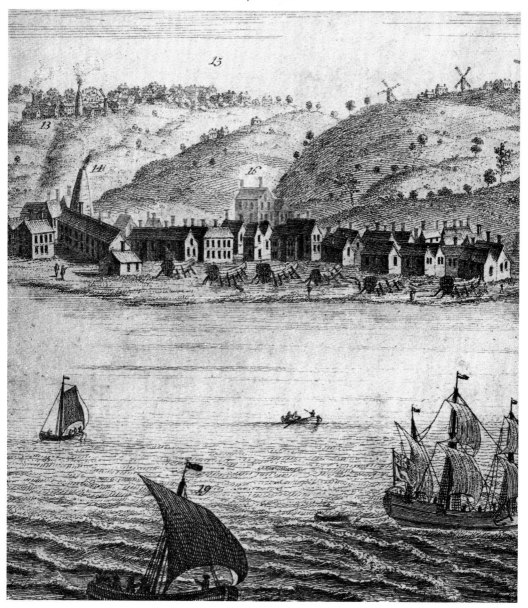

Waterfront view of early eighteenth-century shipbuilding in Liverpool. (Courtesy of Liverpool Athenaeum Library)

A SAILOR'S LIFE

Liverpool has never been an official Royal Naval port; it was always the centre of international, free-booting, merchant shipping trade. Throughout the seventeenth and eighteenth centuries in particular, and until 1856, Liverpool employed many sailors on fully armed sailing ships known as 'Privateers'. These were vessels belonging to private individuals or companies who had been granted a 'Letter of Marque' by the British Admiralty. These gave captains the authority to 'apprehend, seize, and take the ships, vessels, and goods' of the nation or nations with which Great Britain was currently at war: and we were usually at war with some country or other — generally the French but also the Spanish, Dutch, and the Americans. This meant that any enemy vessel, and its cargo, was considered 'fair-game' for capture and seizure.

Liverpool vessels took an active part in this form of legal, government-sanctioned 'piracy', and made lots of profit for their captains, owners and their crews. They then spent money in the port, and paid anchorage fees and customs duty as well, so Liverpool Borough itself also made a great deal of money from the privateers. Indeed, in 1779 alone, 120 Liverpool privateers sailed into the port with cargoes valued at around £1 million — at eighteenth-century prices!

To obtain a berth on a privateer was the main goal for many Liverpool seafarers because there would be adventure aplenty. Sailors could also return from such a voyage with purses bulging with gold from their share of the bounty. Piracy for fun and profit was the name of the game. However, life aboard ship could be harsh.

If a young man wanted to make a life for himself at sea then he would need to do so from the age of 13 or 14. Throughout their teenage years, such volunteers would train at the hands of older seamen, often as apprentices to learn specific skills. Or they might sign on board as a ship's boy, learning as much as they could as they acted as a general dogsbody on the voyage. By the time these young men reached their early 20s they were known as able-seamen; they were fit, strong, and able to climb ropes and rigging, and play their part in keeping their vessels afloat during squalls, tempests and even tornadoes!

Mariners had to be able to cope with extremes of temperature, especially as many ships sailed wherever trade was most profitable, no matter how inhospitable the climate. Heatstroke and sunburn were common, as was hypothermia and frostbite. Sailors could be at sea for anything from three weeks to three months, or sometimes for years, and you could well spend an entire voyage mostly wet through.

The food on board ship was generally quite bad, and a lot depended on the generosity of the ship-owners and captains, who decided what provisions a vessel would carry. Mostly though, how

Edwardian postcard showing sailors aboard a privateer. (Discover Liverpool Library)

The Liverpool privateer *Mentor* captures the French ship *Carnatic* in 1778. (Courtesy of Liverpool Athenaeum Library)

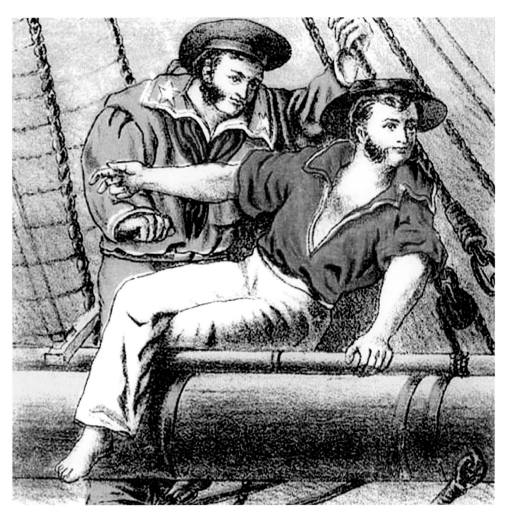

A young sailor learns his trade from an older sailor. (Discover Liverpool Library)

well-fed the crewmembers were depended on the skill, or otherwise, of the ship's cook, who was not usually a capable chef (often he would only know how to boil or stew food.)

A basic diet would consist of salted pork or cured ham and dried vegetables, unless fresh food could be bought in the various ports the vessel visited. Fresh fruit, especially lemons and limes, were important because they kept the dreaded disease of scurvy at bay. Ship's biscuits were standard fare as they could fill otherwise empty stomachs, even though they were hard and dry, and were often infested with weevils. Light ale (known as small beer) was drunk more than water as it stayed fresher for longer.

Most of the work on board ship was physical, particularly on sailing ships. A sailor's job would consist mainly of maintaining and adjusting rigging, and of furling and unfurling sails. On three- or four-masted ships men could often be working at heights of over 150 feet. Falls were frequent, especially in rough conditions and as men got older and weaker. If they fell from a height into the sea then they might survive. If they fell to the deck they would be killed outright, if they were fortunate. If not, then they were likely to be horribly crippled and forced to beg for a living for the rest of their lives.

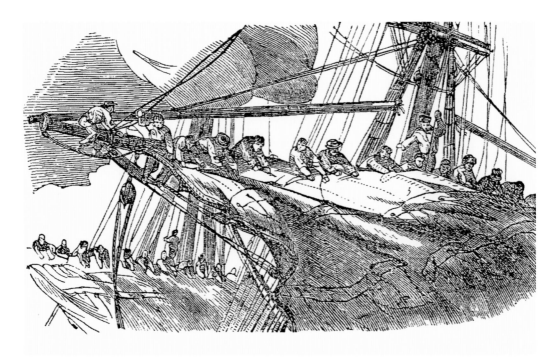

Furling the sails during a squall. (Discover Liverpool Library)

Death at sea was commonplace; from storms and shipwreck; from disease, starvation and brutality; through enemy action in time of war; and by simple accident. If there was a death on board ship then a burial at sea would take place, if there was a body. However, this was something that every sailor dreaded, because there was no guarantee that the angels would know where to find his soul at the bottom of the ocean, and so they would not be able to carry him up to heaven. Indeed, even as Captain Horatio Nelson (1758–1805) lay dying at the Battle of Trafalgar, he whispered, 'Don't let them bury me at sea'. His body was indeed brought back to England (preserved on board in a cask of brandy), and he lies at rest in St Paul's Cathedral. But for an ordinary seaman, 'Davy Jones Locker' (the bottom of the sea) would most often be his final resting place. He would be sewn up in his own hammock, with the last stitch through his nose to ensure he was dead, with weights, or a cannon ball, inside his canvas coffin to make sure he would sink to the bottom.

Because the number of ships using the port was increasing exponentially, more and more sailors came to Liverpool looking for a berth, as did men seeking labouring work. Until the advent of modern contracts of employment, and of required qualifications and provable experience for a berth at sea, one of the great attractions of life as a merchant seaman was the freedom and independence that went with it.

During the eighteenth and nineteenth centuries especially, there were so many vessels trading out of Liverpool that work was plentiful, both at sea and the harboursides, particularly for men who were strong and healthy. A man wanting to go to sea could walk the length of the port's docks and wharves, checking how well a ship was built and maintained, and therefore how seaworthy she was: sailors wanted to arrive safely at their destination ports.

He would also enquire where each vessel was bound, seeing if its destination offered adventure and excitement, or perhaps a range of other physical or financial attractions. He

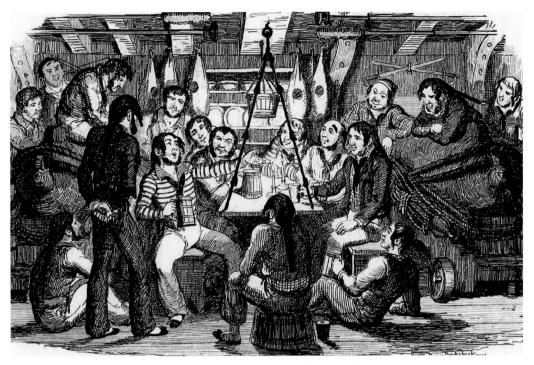

Off-duty sailors carousing below decks. (Discover Liverpool Library)

would also ask what its cargo was, as this would indicate how much labour he might be expected to undertake, or if it was a product or commodity he might benefit from.

If a vessel was 'shipshape', looked like she would sail on 'an even keel', and the sailor liked 'the cut of her jib' then he would offer himself as a crewman to the ship's master. He was generally quickly signed up for the voyage, particularly if he had any previous experience at sea.

Whether or not the seaman stayed with the ship once it reached its next port depended on how good the voyage had been, how well the ship had performed, and how the crew had got on together. How he had been treated by the ship's captain and senior crewmen was also important, as was how much he had earned and how much he would be paid on the ship's next voyage. If any of these criteria did not meet with his approval, then the sailor would simply seek a berth on another ship. He was often prepared to wait in port until one met his requirements, providing he had not spent all his pay of course!

Sometimes, however, a sailor wandering the docks or streets of Liverpool, or taking a drink in one of its many inns, taverns or grog-shops, might find that he had no choice at all about his next ship, or its destination, or his length of service on board if he was unfortunate enough to fall into the hands of the feared Press Gang.

During the eighteenth and early nineteenth centuries in particular, the British Royal Navy was the strongest and largest in the world. But, life aboard Royal Naval vessels was particularly cruel and often far too short; much more so than on merchant vessels. Regular recruits were needed to keep up crew numbers aboard naval vessels, but volunteers were few and far between. This was because Navy sailors lived on board in cramped and unhygienic quarters, were ill-fed, poorly heated, and underpaid. They were also exposed to the threat of violent death at war and naval discipline was brutal. Death was the penalty for most crimes, while

A Liverpool sailor around 1750. (Courtesy of Liverpool Athenaeum Library)

punishments for even the most trivial offences could also be fatal, and usually involved flogging with the cat-o-nine-tails. This consisted of nine thin ropes, each about a yard in length and bound together at one end to form a handle. Each rope was waxed, had a large knot at the end, and other knots along their length.

When repeated lashes were forcefully 'laid on' by a burly bosun, in front of the entire crew assembled on deck, the torn flesh of the victim caused him great pain, and the resultant bleeding and shock might kill him. Those who survived this beating were then dragged below deck to have salt rubbed into the wounds. This was, ostensibly, to prevent infection, but it only exacerbated the torment, hence the proverbial phrase 'rubbing salt in the wounds'.

This regular brutality was well-known and deeply repellent to ordinary landsmen as well as to experienced merchant seamen, so volunteers for service in the Royal Navy were rare indeed. Therefore, in order to maintain acceptable levels of manpower, the government found it necessary to forcibly enlist (preferably experienced) men into the 'Senior Service'. Because Liverpool was such a significant port, with great numbers of ships coming into harbour every day, the town was a prime target for the Press Gang.

Although often far too late, the alarm cry of 'Hawks abroad!' would be shouted through the narrow, cobbled streets and alleys, warning people that the dreaded press gang was in town. These teams of extremely violent men, under the authority of the King, roamed the streets by day and night, leaping on unsuspecting passers-by or those coming out of the taverns and inns. After being clubbed senseless and then securely bound, these innocent men were abducted

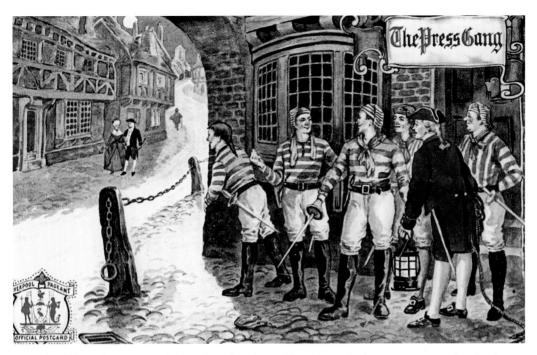

An Edwardian postcard showing the Press Gang in wait for an unsuspecting landsman. (Discover Liverpool Library)

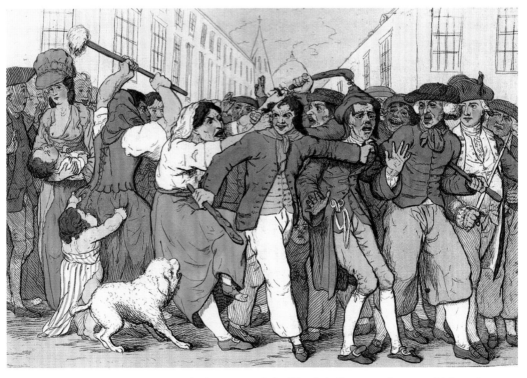

Local citizens come to the aid of a victim of the 'Hawks'. (Discover Liverpool Library)

from their homes, families and jobs with little hope of escape. They could be away at sea for years, if, in fact, they were ever seen again!

Pressed men made up about half of every Royal Navy ship's crew, and by the law of the day they had no redress. In fact, 'failure to allow oneself to be pressed' was punishable by hanging. This meant that if you were not fast enough to run away from the gangs, or strong enough to extricate yourself from their grip, then you were at their mercy (unless, of course, your friends and neighbours came in on your behalf and successfully fought off the thugs).

In Liverpool, the town's citizens were determined to prevent the press gangs succeeding in their ruthless work. Pitched battles between the press gangs and groups of townspeople were frequent and bloody, as local men often fought to the death rather than fall into the clutches of the gangs. But such victories were very few and far between.

With the end of the Napoleonic Wars, in 1815, the activities of Press Gangs steadily reduced, although the British Navy still relied heavily on this method of 'recruitment' until the 1830s. By this time though, and thanks to the work of outstanding seamen such as Admiral Lord Nelson, conditions for ordinary seamen in the British Navy steadily improved, as did their rates of pay. The Royal Navy found itself manned more and more by volunteers and career sailors.

Even though impressment has not, strictly speaking, ever been formally abolished, by the middle decades of the nineteenth century impressment was no more. This was to the great relief of merchant seafarers and ordinary able-bodied men in ports around Britain, and to their wives and families.

As the nineteenth century became the twentieth, conditions for men at sea gradually began to improve, especially with the advent of the trade union movement, more enlightened ship-owners and political legislation. But what of the port itself, its harbour and docksides, and the people who worked in and around them? That itself is quite a story.

THE CROSSROADS OF THE WORLD

The first ships of any significance to set sail from Liverpool had been those that formed part of King John's invasion fleets in the early years of the thirteenth century. But it was not until the mid-seventeenth century, and the beginnings of international trade, that shipping really began to develop as a major source of commerce for the town and its port.

After the English Civil Wars (1642–1651), and then as the seventeenth century became the eighteenth, a steady increase in Liverpool's maritime trade propelled it into global prominence. As a result, the need to accommodate an increasing number of vessels in a safe harbour became more pressing.

The first known reference to any sort of dock or constructed berth at Liverpool is from the Town Records for 1551, when a water bailiff was appointed. His job was to prevent obstructions in the port and to manage waterborne traffic in the Pool. It is likely that a more permanent harbour for ships than had probably been the case before would have been constructed at that time.

From the time of the founding of the town there had also been an anchorage at the foot of Water Street (originally called Bank Street as it was on the riverbank). Many vessels embarking or disembarking passengers, or troops, dropped anchor at this point. However, this was only a point for single vessels to berth, and the Pool was always the busiest and most accommodating harbour in the town.

At the end of the seventeenth century, the Pool of the Mersey covered the area where Canning Place and the Liverpool ONE retail development now stand. However, this vital berth and anchorage were now beginning to silt up. Not wanting to go the way of their former rival, the Port of Chester, the Corporation of Liverpool recognised that urgent action was required. And, whilst the Pool was large, it was also subject to a considerable tidal range; this was a problem for all vessels using the Port, including the small craft that were by then regularly ferrying across the river.

Another major issue was that ships could only use the Pool when the tide was in, or they would run aground. As well as this, ships were simply tied up at the Pool shore, as there were no wharves or quays. As the harbour became increasingly congested this was no longer adequate.

In 1708, the Corporation appointed Thomas Steers (1672–1750) to design a radical solution to these problems. Born in Kent, Steers was a civil engineer who had served in Ireland with King William of Orange (1650–1702) at the Battle of the Boyne, in 1690. Steers' proposal was to convert the Pool into a wet dock by reclaiming much of the basin shoreline, and by erecting quaysides and a river gate across its mouth. These would then keep vessels afloat during the ebb of the tides.

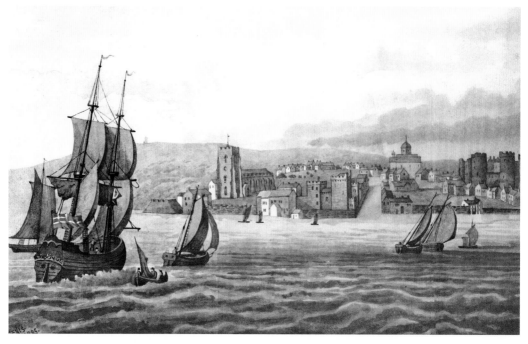

The Liverpool waterfront in the sixteenth century. (Discover Liverpool Library)

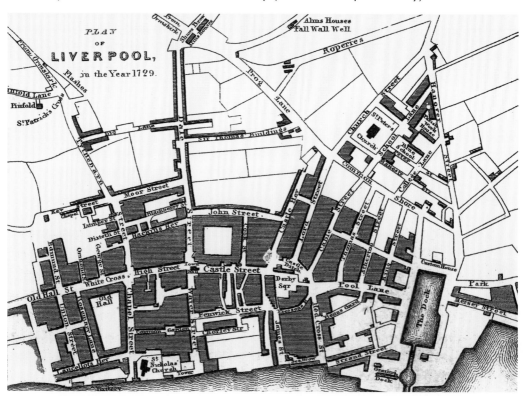

Map of Liverpool town with the first dock to the right. (Discover Liverpool Library)

The concept of such a water-filled enclosure, unaffected by the fluctuating water levels, was a remarkably innovative one for the time. Steers began work in 1710, and used largely local labour to build an embankment across the mouth of the Pool. After five years, and with an expenditure of £11,000, the dock was completed in 1715. This was the first enclosed commercial wet dock in the world.

Ships and water could now enter the dock at high tide, and closing the gates prevented the water running out of the dock as the tide receded. The effect of this was that a ship could unload in 1½ days as opposed to the 12–14 days that it had previously taken, especially when such cargo handling was at the mercy of the tidal flow and of any stormy conditions.

The impact of the opening of Steers' dock was immense, and Chester, Bristol and London were among a number of British ports that lost significant amounts of trade to Liverpool as a result. (London's first dock was not opened until 1802.) They did not have the same facilities that Liverpool could now offer to the world's merchants and soon the town took a lead in international commerce.

Before long though, the new dock became inadequate for the resulting dramatic rise in demand, and Liverpool had to create more wet and dry docks. The next dock to open was South Dock, in 1753, and, as its name implies, this was sited just south of the original dock. It was from this time that Liverpool's first dock began to be known as the 'Old Dock'.

In due course, another larger dock was opened in 1771. This was named George's Dock after King George III (1738–1820). Even so, this eventually became too small to cope with the expansion in trade and in ship size and, in 1825, it had to be rebuilt and enlarged.

However, Britain was soon at war with America, during the American War of Independence (1775–1783), and this resulted in a major drop in trade. This also produced serious unemployment in Liverpool; so much so that the degree of poverty that followed caused sailors to rebel and hold the town by force for several days. Records show that it was quite a struggle for the army to regain control of the town, and a number of people lost their lives

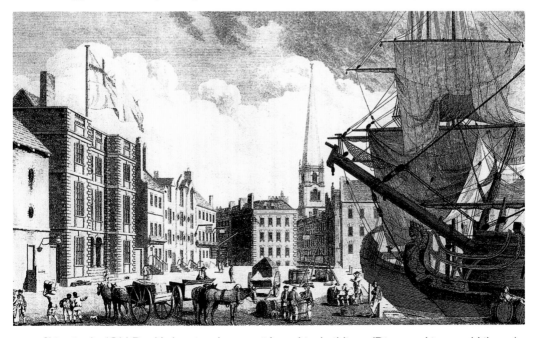

Ships in the 'Old Dock' showing the quayside and its buildings. (Discover Liverpool Library)

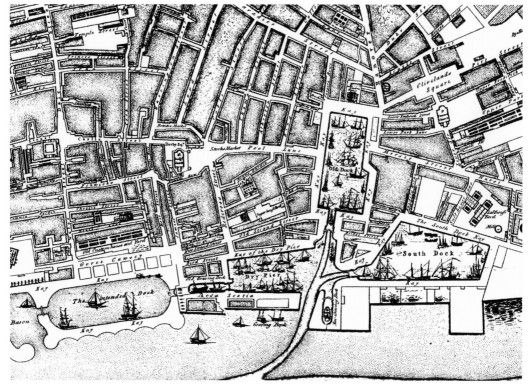

Map from 1765 showing Liverpool's newest docks. (Discover Liverpool Library)

in the violence that followed. However, by 1800, trade had recovered, and increased, and the registered tonnage of shipping in Liverpool that year was third only to London and Newcastle. The availability of paid work also recovered, at sea and on land.

In 1788, the King's Dock opened, followed by Queen's Dock in 1796. In fact, by the beginning of the nineteenth century Liverpool had become the second greatest seaport in the kingdom. The number of sailors setting out from the port had trebled as had the number of locally owned vessels. The tonnage of ships entering the town now increased tenfold and this fuelled continued growth and expansion for the next 100 years.

One of Liverpool's most labour-intensive though highly lucrative forms of seafaring was whaling. Although relatively short-lived as a source of revenue for the town, from around 1750 until the early decades of the nineteenth century this trade was a vital part of the maritime economy of Liverpool. It also provided well-paid if highly dangerous work for a very particular type of Liverpudlian seafarer. These were tough, experienced sailors; men of strength, tenacity, and courage (or at least bravado). They sailed into the most inhospitable of waters in pursuit of the largest animals on the planet.

Hunting these mammoth creatures for oil, meat and for precious and rare ambergris demanded every ounce of stamina from whale hunters. But, most of all, it required endless patience. Weeks or sometimes months might pass before the water spouts of their prey were sighted. Then the lookout would give the cry that lifted the hearts of the profit-hungry and risk-driven seafarers: 'There she blows!'

Whaling ships generally travelled in small fleets, and they would all lower long-boats, which between twelve and fifteen crewmembers would row at break-back speed after the schools

of sea giants. In the prow of each of these stood the most important and, after the Captain, highest paid member of the crew, the Harpooner. These men would shoulder their long, heavy, barbed, forged-iron javelins of death. Once the long-boat was sufficiently close he would hurl his metal spear deep into the thick flesh of the massive mammal.

A single harpoon would seldom kill a whale outright, but three, four, or five would maim it badly enough to quickly bleed the animal into an exhausted death. Rolling onto its back, the whale would then be hauled back to the ship, to be cut up and rendered down into the products that the whale-hunters sought. Whale oil lit the lamps and lubricated the machinery of the Industrial Revolution (c.1760–c.1830); whale meat was eaten; blubber was used in the manufacture of soap and leather goods; and ambergris was an essential ingredient in the most costly perfumes and exotic aphrodisiacs.

The industry reached its peak by 1788, when twenty-one vessels were registered in Liverpool as whalers. In that year this fleet sailed for the Arctic and returned with the oil and blubber from seventy-six whales. Even the hold of just a single vessel filled with barrels of whale oil would make its crew, its Captain, but mostly its owners extremely wealthy.

Though profits were great, so too were the risks. Frequently, whales escaped their hunters, or turned on them and destroyed their long-boats and drowned their men. Indeed, in 1789, four whaling ships from Liverpool were lost at sea with all hands. In one famous case, in 1820, the New England whaler, *Essex*, was completely destroyed by a mammoth white whale that sought it out and seemed to deliberately attack it. Only a few of its crew survived. In 2016, the story was told in the film *Heart of the Sea*.

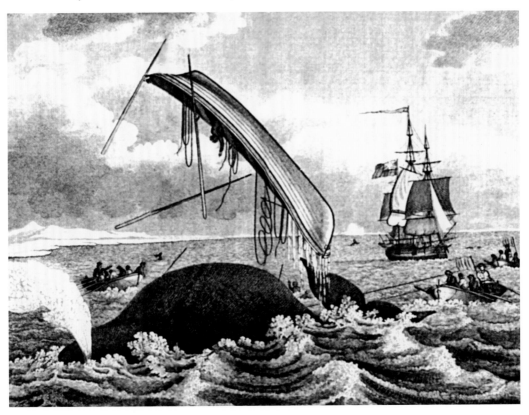

The hazards of whaling. (Courtesy of Liverpool Athenaeum Library)

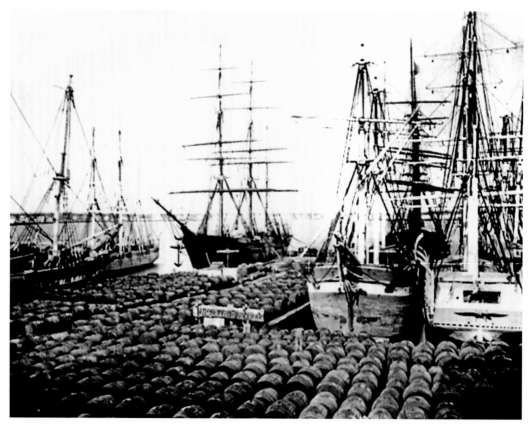

Whaling fleet unloads its full casks of whale oil. (Courtesy of Liverpool Athenaeum Library)

The last permanent whaler operating out of the Port of Liverpool appears to have been a ship named the *Baffin*. This was the first whaling ship to be actually built in the port, in 1820, by William Scoresby (1760–1829). His son, William Scoresby Jnr (1789–1857), set sail in the summer of 1822, on a scientific voyage to Greenland. He reported his findings in his book entitled, *A Journal of the Voyage to the Northern Whale Fishery, including Researches and Discoveries on the East Coast of West Greenland made in the Summer of 1822 in the ship the Baffin of Liverpool*.

Herman Melville (1819–1891), the American author, visited Liverpool in 1839 and was so inspired by the wonders of the port, and by William Scoresby's book, that he went on to write his great novel about whaling, *Moby Dick*, in 1851. He also used the disaster of the *Essex* to shape his plot.

Melville arrived in Liverpool, directly from New York, on his first ever sea voyage at the age of 20. He was working as a cabin boy aboard the *St Lawrence*, and he stayed in the port for a month before sailing out again on the same vessel. He was drawn back to Liverpool once again, in 1856, when he stayed much longer. Many historians believe that it was Melville who was the first person to make the connection between Liverpool and the Liver Bird, stating that the town had been named after this mythical seabird.

The whaling industry in Liverpool was, for a time, a major provider of work for Liverpool sailors and for men back home on land, processing and transporting the products of a hunt. The culture and community associated with the trade also added to the character as well as the mythology of the port. Nevertheless, by the middle of the nineteenth century no more ships sailed from Liverpool in pursuit of great whales; white or otherwise.

Herman Melville, American author
of *Moby Dick*. (Discover Liverpool
Library)

In 1811, the Old Dock was filled in and replaced by a massive dock to the north, which became Princes Dock, opening in 1821. Clarence Dock was opened in 1830, to take steamers. Consequently, this dock was located some distance northwards, to avoid the risk of fire to the sails and rigging of any adjacent sailing vessels. Indeed, from the Dingle in the south to Seaforth in the north, and covering a distance of some 7½ miles, Liverpool's dock network became one of the largest in the world; at its peak totalling 130 individual docks.

Soon great warehouses to store ships' cargoes were also being built, both on the docksides and inland. All of this continuous construction work provided labour for thousands of men, and the population of Liverpool continued to grow rapidly as they moved into the town with their families. By the mid-nineteenth century, the port and its dock network was internationally famous.

The docks made Liverpool great because they were a major gateway to Britain and the rest of the world. From the original Old Dock, Liverpool's vast wharves and quays system grew to a network that was vital to international trade, emigration and the development of the British Empire. Even today the total lineal quayage of the Liverpool Docks is over 38 miles, comprising 653 acres of water. This is a record of achievement that truly demonstrates the degree of enterprise and the determination of the business community and entrepreneurs of the city. This was the product of the labour of the tens of thousands of men and women who, over the last 300 years, have built and laboured in and around Liverpool's waterfront.

As well as importing goods into the country, Liverpool was the point from which tens of thousands of people emigrated from the Old World to the New, and to the four corners of the expanding British Empire. Emigration to America had begun almost as soon as the Colonies had been founded, in the seventeenth century. However, once America gained her

independence from Britain, in 1776, the numbers of emigrants increased rapidly, reaching a peak in the mid-nineteenth century.

Between 1825 and 1860, about two-thirds of the total number of people who emigrated to America and Canada from Europe did so through Liverpool. This totalled about 3½ million people sailing to America, and 350,000 to Canada, during this thirty-five-year period alone. In fact, between 1840 and 1914, almost 35 million Europeans left the Old World for the New.

Even though the ports of London, Bristol, and Glasgow also saw global emigration on a large scale, most people seeking a new life overseas passed through Liverpool. Some came from Britain and Ireland, and many from Scandinavia and Germany, but by the end of the nineteenth century most were from Austro-Hungary, Italy, Eastern Europe and Russia. During these long decades, 4,750,000 passengers sailed from Liverpool on ships owned by companies like Cunard and Inman. And, in 1887 alone, 199,441 emigrants sailed from the port. Of these, almost 69,000 were from continental Europe, over 62,000 were British, and over 68,000 were Irish.

These people not only passed through Liverpool's docks but many of them made the town their home, thus creating one of the oldest, most culturally rich and varied communities in the country. There are now settled communities across the Liverpool and Merseyside area, including Middle-Eastern, Afro-Caribbean, French, Polish, Russian, Indian, Bangladesh, Pakistan, Chinese, Croatian, Vietnamese, Somali, Jewish, Sikh, Bahá'i, Moslem, Hindu, Protestant and Catholic, to name a few. The positive significance of the diversity of Liverpool's commercial and community life cannot be underestimated.

The arrival of so many emigrants provided one of the greatest and most dependable sources of income for the town. These desperate people, if indeed they had any money, might need lodgings until their ships were ready to set sail. However, not everyone who benefitted from this financial opportunity was entirely honest. On the outskirts of the town centre could be

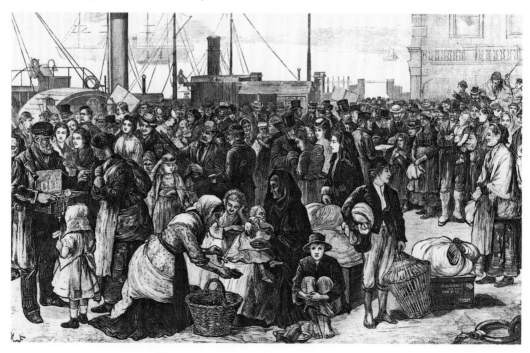

Emigrants on the dockside. (Discover Liverpool Library)

found comfortable and clean rooming houses, but few emigrants were able to afford these. Most ended up putting their meagre travelling funds into the capacious money pouches of the landlords of unsanitary, overcrowded and often violent flop-houses.

These establishments seldom offered an actual bed; more often than not just a straw mattress on the floor. Some travellers might be lucky enough to rent a hammock for the night. This might keep you out of the reach of the rats, cockroaches and (some) of the lice, but you would likely wake in the morning to find that your luggage and clothing had been stolen.

Of course, not all landlords were dishonest or exploitative; not every street urchin was a pickpocket; not every shopkeeper sold over-priced or substandard goods; and not every burly man was a robber, footpad, or press gang member. Most Liverpudlian tradespeople took a pride in the quality of their goods and services, as well as in the care of their customers, and the majority of ordinary locals were welcoming and friendly.

There was plenty of honest money to be made in this thriving and growing metropolis, particularly throughout the nineteenth and twentieth centuries. The butchers, bakers and candlestick makers; the tinkers, the tailors, and the soldiers and sailors; the carters and coachmen, the porters and the dockers; the cobblers, the hatters, the apothecaries and the grocers, to name just a few, made good and substantial livings from the emigrants.

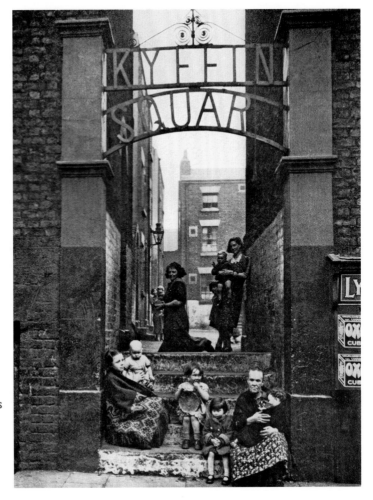

Many of the immigrants who made Liverpool their home ended up in slum courts and tenements. (Discover Liverpool Library)

The numbers of people passing through Liverpool was such that local transport provision, and customs and public health facilities had to expand exponentially to keep pace. In 1895, the Mersey Docks and Harbour Board built Riverside station at Princes Dock. This was reached by rail through a long tunnel from Edge Hill to Waterloo station, standing opposite Waterloo Road and facing the river. The dock railway then ran across the south–east corner of Princes Half-Tide Dock, alongside where the riverside roadway now runs. This served not only emigrants but also the wealthy of the world who, by the end of the nineteenth century, were taking advantage of the rapidly increasing numbers of international luxury liners to sail the oceans for both business and pleasure. However, those less than wealthy passengers who were travelling to new lives abroad had to face many hardships.

Consider what was truly involved for these people in their attempt to improve their lot in life: after leaving behind their loved ones, escaping from poverty and famine, persecution and pogrom, they faced the uncertainty and confusion of travel across Britain, where the language and customs were strange. Then, as many of them were rural peasants, they would be overwhelmed by the size, noise, pace and pressure of 'The Second City of the British Empire'.

Having managed to avoid, or perhaps having fallen victim to the pickpockets, conmen, and others who had sought to fleece them as they wandered the streets of Liverpool, they then had to suffer the indignity of personal searches and medical inspections. This was to ensure that they were not infectious, and to safeguard against them transmitting disease when they left. Indeed, Liverpool had the very first Port Health Authority in the world, and the first

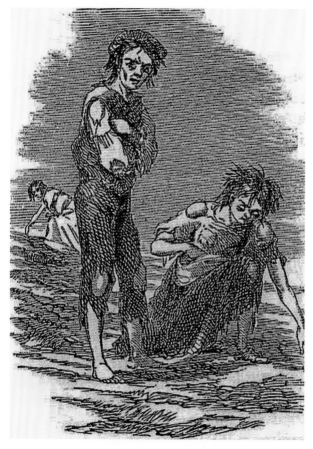

Starving victims of the Irish Potato Famine of 1845 and '46 who came to Liverpool in desperation and with hope. (Discover Liverpool Library)

Medical Officer of Public Health, Dr William Henry Duncan, in 1847. Next, they boarded their vessels and looked for a secure place to call home whilst on the ship, often for weeks and in all weather conditions.

And so, unlike most other British industrial and commercial cities, which developed largely around particular manufacturing industries or products, Liverpool grew around its port and worldwide maritime trade. This gave the town a global outlook and international ambitions, and therefore it was the least provincial of all Britain's major towns and cities. To some extent it is true to state that Liverpool stands with its back to Britain and its face to the world.

One factor that makes the people of the city so connected to the River Mersey and to the sea is that the bulk of its population live so close to what remains a thriving waterway. Because of this, investment in the city was always focussed on the port and on cargo and goods handling, and much less on industry and manufacturing. However, many of the raw materials and commodities that arrived in the port were processed here in some way, before being transported onward by land or sea. The trades associated with these cargoes became prominent and highly profitable, and most had their own professional associations and exchanges.

This was especially the case with cotton, corn, fruit, and meat. Other significant trades that had a level of processing or manufacturing in Liverpool included coal, timber, tobacco, canned goods, and general produce. However, and particularly from the late seventeenth and eighteenth century, certain industries other than shipping drove forward manufacturing in the town.

THE BIRTH OF INDUSTRY IN LIVERPOOL

Many of the new immigrants to Liverpool brought with them existing businesses and overseas interests. Town records show that in 1666, the Liverpool ship *Antelope* set off for Barbados with a cargo of various goods, returning the next year with sugar cane. This was also the first cargo ship to travel from Liverpool to America. Within ten years, twelve ships were plying between the port and Barbados, and also to Virginia, returning to Britain with a cargo of tobacco. However, the first processed commodities that became profitable in the industrial life of Liverpool were sugar and salt.

The year 1667 saw the Great Fire of London and a resulting influx of people into Liverpool, especially entrepreneurs. One of Liverpool's leading burgesses, Sir Edward Moore (1634–1678), of Bank Hall, recorded his sale of a piece of his land to, 'one Mr Smith, a great sugar baker at London … worth £40,000'. This land was on the north side of Dale Street, between the present Moorfields (named after his family) and Cheapside.

It was the arrival of merchants like Mr Smith, and many others like him, that prompted other burgesses to begin investing in the importation of not only sugar but of other plantation grown crops. These were produced on the slave-worked estates of the West Indies and the southern states of America, like Virginia.

At the industry's peak there were four large sugar refineries in Liverpool: Fairrie's refinery was established in the town in 1797, Macfie's in 1838, Crosfield's in 1850 and Henry Tate's in 1875. These would eventually merge into the Tate & Lyle Group, which, by the early 1950s, was providing the bulk of Britain's sugar requirements. Such was the importance of the commodity that there was a large community of sugar brokers in the town, including some with significant global interests and influence.

Coming into Liverpool through the Aintree, Vauxhall and Kirkdale districts, the Leeds–Liverpool Canal provided increased work opportunities for that densely populated part of the town. It also became a great recreation centre for local children and young men, especially in sections passing the sugar refineries in Vauxhall and Kirkdale. This was because the refineries discharged hot water into the canal as part of their manufacturing process, turning the 'cut' into a heated swimming pool. Making sure to dodge the barges these 'water rats', as they became known, came to splash, swim and play in the cut from all over north Liverpool.

The availability of refined sugar in such large quantities in Liverpool fuelled the establishment and growth of other important trades here and across Merseyside. These included sweet, toffee and chocolate manufacturing, fruit-preserving, confectionary, baked goods, mineral waters and soft

Bank Hall, the stately home of Sir Edward Moore. (Discover Liverpool Library)

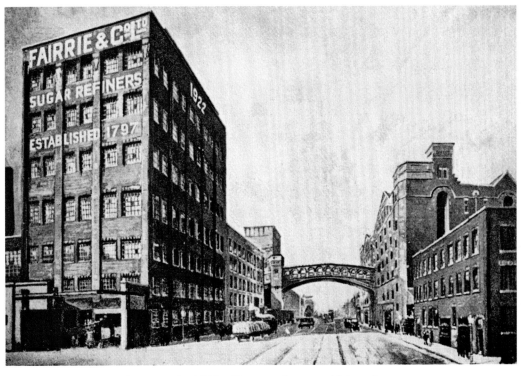

Fairrie's Sugar Refinery in the 1920s. (Discover Liverpool Library)

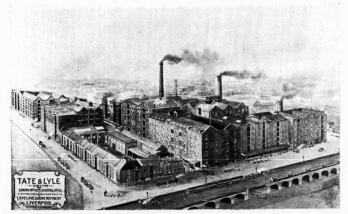

Tate & Lyle Sugar Co. advertisement. (Discover Liverpool Library)

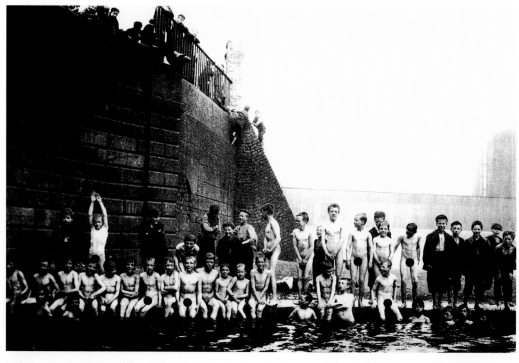

'Water Rats' swimming in the 'hotties' in the Leeds–Liverpool canal. (Courtesy of Liverpool Athenaeum Library)

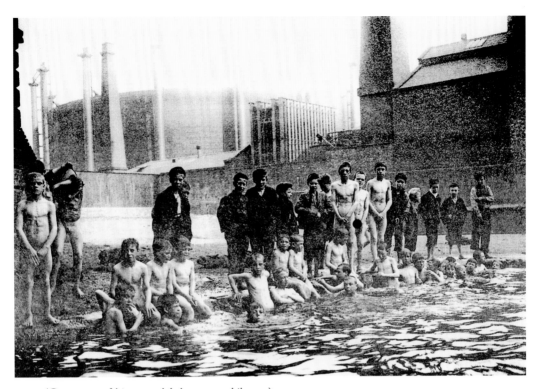

(Courtesy of Liverpool Athenaeum Library)

drinks. Consequently, as a source of employment of both skilled and unskilled workers, sugar was very important.

Of equal value to the economy of Liverpool, and as a provider of work for its people, at least until the early twentieth century, was the salt industry.

Between the southernmost district of Liverpool at Speke and its nearby neighbour, the tiny, delightful and surprisingly rural township of Hale, a narrow largely unmade road winds down to the River Mersey. This almost entirely uninhabited stretch of coast is known as 'Dungeon Point' and the roadway is known as 'Dungeon Lane', but it has nothing to do with prisons or incarceration. In fact, it is probably derived from the Anglo-Saxon words 'dunge' or 'denge', meaning 'marshland' or 'land that adjoins marsh'. Today only an isolated farmhouse and some outbuildings stand at Dungeon, surrounded by a large expanse of heathland and sandflats. However, this was once an important and thriving centre of the salt-refining and shipping trade.

Until the ready availability of simple and economic mechanical refrigeration, the usual way to preserve food was to either cure it, or liberally coat or pack it in salt. For meat and fish in particular this slowed the decaying process or at least disguised the taste of its rottenness! This was especially important in a seafaring town like Liverpool, where long sea voyages needed great quantities of long-lasting provisions, and where salted meat was in great demand.

The local salt-refining trade really developed following the discovery of rock salt, first near Runcorn in Cheshire, in 1670. In 1697, a salt refinery with a processing centre and a sandstone quay was established at Dungeon by Sir Thomas Johnson (1644–1728). He served as both MP and Mayor of Liverpool and Sir Thomas Street was named after him.

It was to Dungeon that flatboats and barges brought rock salt from other Cheshire salt fields at Northwich, Middlewich, Nantwich, and Winsford. It was then refined and shipped onwards.

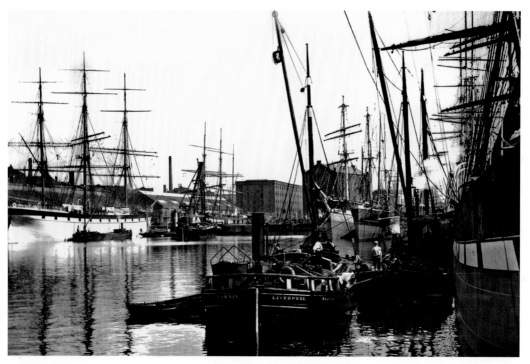

Salthouse Dock, once the centre of Liverpool's salt-refining and export trade. (Courtesy of Liverpool Athenaeum Library)

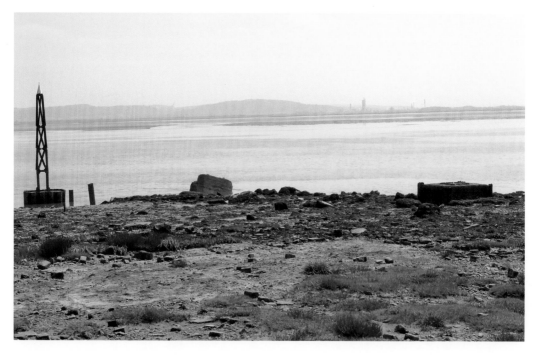

All that remains of the jetty at Dungeon Point today, once a thriving centre of the salt-refining trade. (Discover Liverpool Library)

The refining process involved the dissolving of rock salt in seawater from the Mersey, which was heated in large metal pans over coal fires. The volume of salt produced using this basic method was considerable, as were the quantities of coal needed to continuously operate the burners. This kept the salt, coal-mining, and transportation trades in the area active and profitable for their owners.

Every element of this trade was, naturally, labour-intensive; from the mining of the rock salt and the transportation and loading onto flatboats, to the shipping of it to the refineries. Then, the refined salt had to be shipped and stored at Liverpool, ready for export.

Wages for the miners, labourers, and refinery workers were poor, and the conditions unhealthy and often dangerous. Not so for the mine and refinery owners, of course, or for the shipowners, who were often the same men.

Salt soon became a major export from the port of Liverpool because, as well as preserving food on Liverpool vessels, it was an essential commodity for the Newfoundland cod fisheries. From there salted fish was shipped all around the world, but especially to the West Indies where it was used to feed slaves on the plantations. It was also prized because it could be profitably traded for more expensive commodities, such as coffee and sugar.

One such wealthy salt family were the Blackburnes from Orford near Warrington. John Blackburne (1693–1786) had a salt refinery at Garston, close to Dungeon, and he also successfully developed a major salt refinery in Liverpool. This was adjacent to Liverpool's Old Dock. John went on to become Lord Mayor of Liverpool in 1760.

Blackburne's Liverpool salt refinery became so important that the town's second dock, South Dock, which had opened in 1753, soon became known by the name it retains today, 'Salthouse Dock'. This was because of the salt warehouses erected there (now demolished) to service Blackburne's refinery and vessels, which then sailed from that dock.

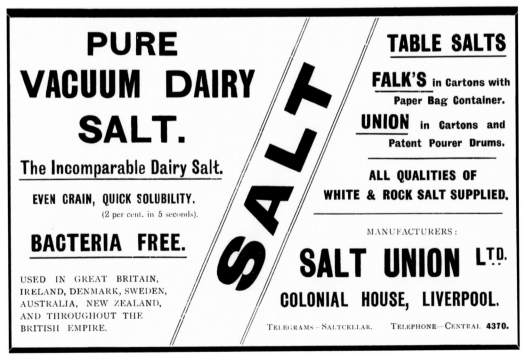

Salt producer's advert from the 1930s. (Discover Liverpool Library)

From the mid-eighteenth and through the nineteenth centuries, the estuary of the Mersey was increasingly used for transporting salt and coal, as well as many other commodities. Even so, by the late 1840s, and for reasons that are unclear, the salt works closed at Dungeon and its wharves and quays were then taken over by a firm of ship-breakers. It was here that schooners, paddle-steamers and, on one occasion, a Victorian warship were taken apart. However, as the river channels near Speke and Hale began to silt up, the shipyard closed in 1912.

All industry then ceased at Dungeon and it reverted once more to being an ignored backwater, with only a few isolated homes and post-industrial riverfront. All that can now be seen at Dungeon Point and the salt refinery that once dominated this now almost desolate stretch of the Mersey foreshore is a small part of the original sandstone quay and some rubble and broken rocks.

Salt has also been particularly essential in iron and steel foundries, and in certain chemical processes. This is why the chemical industry grew so rapidly in Cheshire during and immediately after the Industrial Revolution, close to the salt fields. The mineral was also vital in the pottery industry, which was also an important part of Liverpool's manufacturing economy: after all, people needed containers and receptacles for their sugar and salt!

During the eighteenth century, pottery manufacture became a significant industry in the town, and it thrived to such an extent that the trade rivalled that of the Shropshire Potteries. There were potteries of all sizes across Liverpool, with larger manufacturers near Covent Garden, and at the end of Dale Street, on Shaw's Brow, which would become William

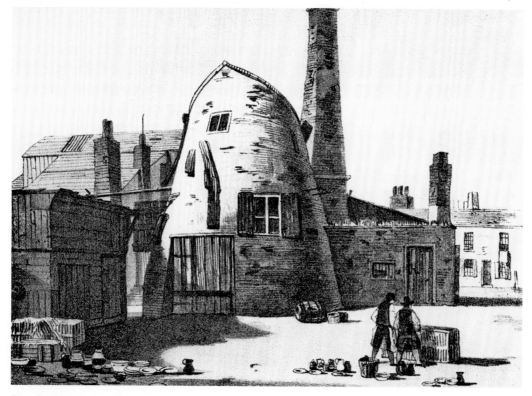

Shaw's Pottery on Shaw's Brow, which would become William Brown Street. (Discover Liverpool Library)

Brown Street. However, public tastes changed and the fine porcelain being produced in these potteries was considered too expensive. This meant that, by 1800, nearly all the Liverpool potteries had closed down.

But there was one new pottery, on the waterfront just to the south of the town centre, which was using new materials and techniques to produce a large range of cheaper and much more practical goods. The demand for household crockery, basins, jugs and, of course, salt cellars and sugar bowls, had increased significantly with the rise of the population and, especially, the middle classes. So when the Herculaneum Pottery was established it soon thrived.

The founder of this new factory was a Cheshire man, Samuel Worthington (c.1793–1847). He opened his pottery in 1796, on the site of a former copper smelting works. Coal to fire the kilns came from the nearby South Lancashire coalfield, and clay for potting was excavated at many places in the Liverpool area. China clay, for making fine porcelain, was brought up from Cornwall and the south coast by ship.

Worthington had realised that the pioneering work of Staffordshire potter Josiah Wedgwood, especially using mass-production techniques to make cheaper household wares, was revolutionising the industry. He knew that by using the same methods at his Liverpool site he could sell his products more cheaply and undercut Wedgewood. He was also better placed to export his goods, being directly on the docksides of one of the world's largest and most important ports.

Worthington brought with him to Liverpool a core workforce of fifty or sixty experienced potters from Staffordshire, with their families. They were enthusiastically greeted in the town by a large crowd of people and a band playing welcoming music. These included many local pottery workers who had lost their employment when their own works had closed but who now had new jobs.

The Herculaneum Pottery was soon doing very well and expanded its range. Many everyday wares were now produced, including roof and wall tiles, cups, mugs, wine bottles, candlesticks, puzzle jugs, salvers, medicine pots, and large quantities of chamber pots. Many of these products were skilfully and beautifully hand-painted by pottery artists, thus increasing their marketability. A major innovation was the production of lines of pottery based on traditional Dutch designs. As a result this became known as Liverpool Delftware.

Before long, Liverpool Delft pottery and tiles became, and remain, world famous. The finished wares were transported from the port around the coast to all parts of Britain, and also across the Atlantic to the ever-growing markets in America. Almost every type of pottery was produced here, including earthenware, which was decorated in a range of designs, both hand-painted and using transfers. These included the famous and very popular 'Willow Pattern' design. Also much sought after was stoneware and, because of its colour, a form of earthenware known as 'creamware'. This was used for large jugs, washbasins and drinking vessels.

Shortly after 1800, the pottery began to make a very fine form of bone china porcelain and the styles of decoration available varied widely. Customers could commission special patterns and illustrations to suit their own taste and budget. Around 1820, the Herculaneum Pottery received a very important commission for the production of a large dinner and dessert service, of over 1,000 pieces, for the recently rebuilt Liverpool Town Hall. This remarkable service survives intact, and in a rich red and gold pattern with the Coat of Arms of the Corporation of Liverpool on every piece. This service was in regular use in the Town Hall until the 1970s, where it is now on show to great effect, in illuminated display cases.

The Herculaneum Pottery. (Discover Liverpool Library)

Liverpool waterfront with the Herculaneum Pottery at the right of the picture. (Discover Liverpool Library)

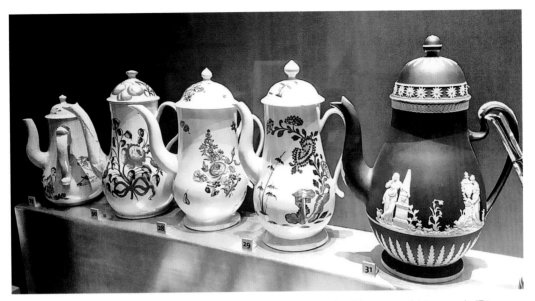

Coffee pots produced at Herculaneum on display in the Museum of Liverpool. (Discover Liverpool Library)

Nevertheless, by 1833, sales were declining as the competition from Staffordshire became increasingly strong. In due course, the Herculaneum Pottery was forced to close. This also brought to an end the glorious 200-year-old pottery industry in Liverpool. In 1841, the site was sold and a new dock was constructed in its place. Eventually, in 1972, the dock itself was closed and filled in. Today a sports and fitness centre stands on the site, together with attractive apartment and office complexes. Surviving examples of Liverpool's pottery manufacture are much prized by collectors.

In the late nineteenth century, there were over 250 watch and clock makers in Liverpool, making this another significant, skilled and labour-intensive industry in the town. Indeed, more gold and silver watches of the highest quality were once made here than in any other part of the world, and they were in high demand.

The manufacture of pocket watches had first become established outside Liverpool, where it operated largely as a cottage industry. Watch tools, movements, and parts were produced by domestic craftsmen in nearby towns and villages, especially Prescot, and the finished watches were assembled in Liverpool.

One of the first successful and pioneering watchmakers in the town was John Wyke (1720–1787), who also made fine long-case clocks. His workshop once stood on the site of the former Magistrates' Court on Dale Street, in what became known as Wyke's Court, and was built by him in 1764. Wyke had begun his business in the town in 1758, and had become so successful that his new premises consisted of a spacious house, workshops, warehouses, out-houses and stables. The entrance was under an archway off Dale Street, and a large garden behind extended almost to Tithebarn Street.

On the site of the former Lewis's department store was once the workshop of Peter Litherland (1756–1805) who, in 1794, invented the rack lever escapement. In 1792, he also patented a watch that beat seconds. Another local watchmaker, Robert Roskell (1790–1847), adopted this invention and exported vast numbers of watches. This included 30,000 to South America alone. One of his clocks stands in stately Speke Hall, in south Liverpool.

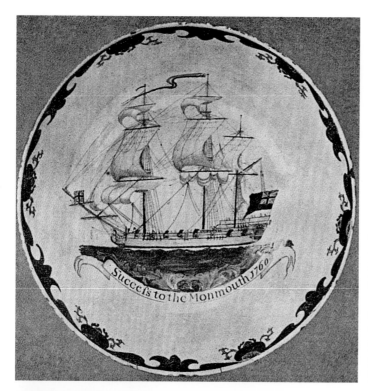

Left: A Liverpool Delftware Ship Plate. (Discover Liverpool Library)

Below: John Wyke's watch and clock factory, Wyke's Court. (Discover Liverpool Library)

Peter Litherland, clockmaker.
(Discover Liverpool Library)

A great many Liverpool watches were bought by emigrants as they boarded ship at Liverpool docks. These precision instruments can still be found keeping excellent time in many countries around the world. However, by the early twentieth century, the Liverpool watch-making industry was eventually overwhelmed by cheaper Swiss and American products.

By the middle of the nineteenth century, and with the Industrial Revolution in full swing, the working population of Liverpool had grown to a prodigious degree. Indeed, Liverpool was one of the fastest growing and wealthiest towns in the world. As well as the handling and processing of sugar and salt, and the manufacture of pottery and watches, many other industries, large and small, now provided work for Liverpudlians. These included Canvass and Sail-Cloth Manufacturers; Brewers; Writing Slate Manufacturers; Boilers and Tank Makers; Chain Cable Manufacturers; Flour Millers; Gunpowder Makers; Gunsmiths; Lock-Makers; Looking-Glass Makers; Opticians and Mathematical Instrument Makers; Vinegar Manufacturers; Umbrella Makers; Tobacco-Pipe Manufacturers; Tanneries; Soda Water and Ginger Beer Manufacturers; Soap Boilers and Tallow Chandlers; Rubber Works; Ropers and Ship Chandlers; and Anchor Smiths. These industries were still minor compared to the dominance of shipping in Liverpool, but they nevertheless contributed significantly to the continually increasing wealth of the town, and of its merchants and leading citizens.

As the nineteenth century became the twentieth, many such companies grew ever-larger; some soon employing many hundreds, if not thousands, of workers. This saw the establishment of what became the largest Soap Works in the country, Lever Brothers at Port Sunlight on

The Wirral; extensive Cement Works at Ellesmere Port; and the ICI chemical factories in Runcorn, Widnes and nearby Northwich.

There were also copper, zinc and other metal works at Widnes; a major candle factory at Bromborough; the Pilkington's glassworks at St Helens; BICC insulated cables at Prescot and Helsby; and Britain's main saltworks at Northwich.

Back in Liverpool some of the largest employers also became nationally and internationally famous. These included Jacob's Biscuits; Bibby & Sons, seedcrushers and oilcake manufacturers; New Liverpool Rubber Company, which became Dunlops; and the Lawton Carriage Company.

Some local individuals became world-renowned entrepreneurs and innovators, such as William Pickles Hartley (1846–1922), who founded Hartley's Jams and Preserves. There was also Frank Hornby (1863–1936), who founded an industry that produced three of the most popular toys of the twentieth century: Meccano construction sets, Hornby-Dublo (Double 'O') model railways, and Dinky Toy model cars and vehicles.

Another of Liverpool's greatest employers and entrepreneurs was Sir John Moores (1896–1993), who established Littlewoods Football Pools, and Littlewoods Department Stores and mail-order catalogues. He became a great benefactor to the ordinary people of Liverpool and beyond, and one of the city's three universities is named after him: Liverpool John Moores University.

Despite all of this economic success, and the very many things that Liverpool and its workers can be proud of, what must not be ignored is that for almost 200 years a number of the town's principal commodities were brought into Liverpool on hundreds of vessels that were an integral part of the abhorrent and shameful 'Triangular Trade'.

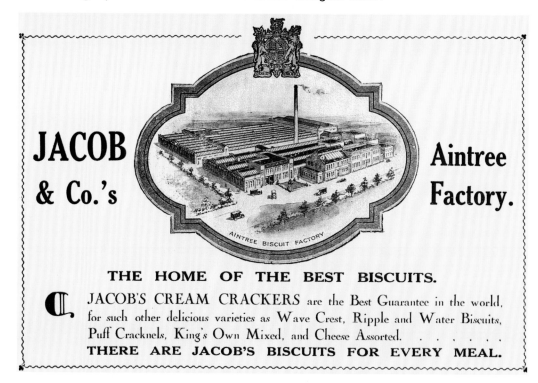

Advertisement for Jacob's Biscuit Co. (Discover Liverpool Library)

THE NEW LIVERPOOL RUBBER Co. Ltd.

VAUXHALL ROAD WORKS

Speciality : "CONSTELLATION" PACKING for High Pressure Marine Engines.
Makers of the famous WALTON Plimsolls & Gymnastics. OVERSHOES. SNOW BOOTS. WELLINGTON BOOTS. SPORTS SHOES, and Rubber Footwear of all styles.

WALTON WORKS.

BALATA BELTING. Rubber & Canvas Belting. Billiard Rubber. Deckle Straps. India Rubber Thread. Mats. Stair Threads. HOSE of all descriptions, Sheet-Valves-Washers. Insertion. HOT WATER BOTTLES.

FOOTBALL BLADDERS and all descriptions of General Mechanical Rubber Goods for Engineering and Ship Building.

Head Office : **292 Vauxhall Rd.** *Shoe Factory :* **Rice Lane, Walton.**
LONDON—19/21 Fore Street Avenue. **GLASGOW—54 Gordon Street.**

Above: Advertisement for the New Liverpool Rubber Co., which went on to become Dunlop's. (Discover Liverpool Library)

Right: Sir John Moores, the founder of the Littlewoods Pools retail empire. (Courtesy of Liverpool Athenaeum Library)

Left: Sir William Pickles Hartley, the founder of the Hartley Jam and Preserve Co. in Liverpool. (Discover Liverpool Library)

Below: Frank Hornby invented Meccano, Dinky Toys, and Hornby Dublo model railways. (Discover Liverpool Library)

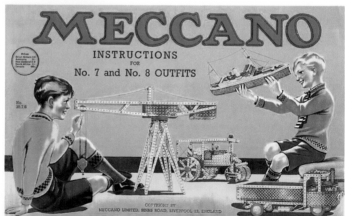

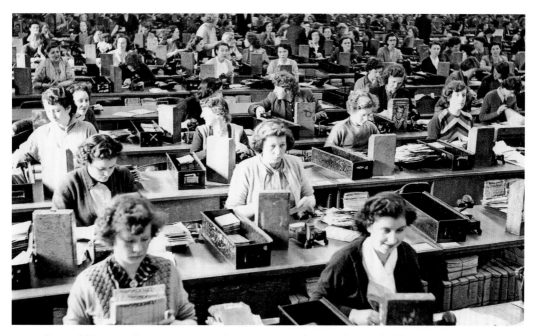

One of Liverpool's many twentieth-century production lines: checking pools coupons for Littlewoods in the 1960s. (Courtesy of Liverpool Athenaeum Library)

'KING COTTON' AND THE 'TRIANGULAR TRADE'

Since the beginning of the eighteenth century the main source of Liverpool's maritime wealth came from the transportation and processing of commodities (in addition to sugar and salt), including rum, tobacco and, in particular, cotton.

'King Cotton' was at the heart of Liverpool's global commercial enterprises. It was also the single most profitable commodity for Britain and her Empire. In fact, the cotton trade and its associated businesses fed the cotton mills and textile industry of Lancashire and beyond for over two centuries. Liverpool quickly became the commercial hub for this international enterprise. Cotton, the slaves that planted and picked it, and the trade in human bondage and suffering thought necessary to sustain it, made vast fortunes for many Liverpool entrepreneurs and their families. Slavery and the cotton trade were also at the root of the American Civil War. The Southern States of America (known as 'The Confederacy') and the town of Liverpool grew rich and powerful from the sweat and toil of the victims of King Cotton.

The Confederacy had no navy of its own, and so commissioned shipbuilders in Liverpool to build one for them. Such firms included Jones Quiggin & Co. who constructed many ships for them, including five blockade-runners. At the same time, in Liverpool's sister town of Birkenhead, directly across the River Mersey, the Laird Shipyard built Confederate warships disguised as merchant vessels. This included the CSS *Florida*, CSS *Banshee*, and the famous CSS *Alabama*. Liverpool had vested interests in the continuation of the American Civil War, and of slavery and the cotton trade, because these all boosted business and employment on both sides of the river.

Raw cotton was first imported into England, primarily through London, during the mid-1600s, but in 1709 this began to change. It was in this year that 2,000 bales of cotton fibre were shipped into the country and some of it came through the port of Liverpool. Over the next fifty years more small quantities continued to pass through the town. This increased after the opening of the Old Dock as the town now had the capacity to handle greater quantities of goods.

With the development and massive expansion of sugar cane plantations in the West Indies, and of tobacco and cotton estates in the Southern States of America, the use of slaves to plant and pick these crops grew exponentially from the end of the seventeenth century, but the first recorded shipment of American cotton into Liverpool was in 1770. However, other 'slave produced' crops were being brought into Liverpool from the beginning of the eighteenth century, as part of what became known as the 'Triangular Trade'. This was so named because it comprised a lucrative three-way ocean voyage.

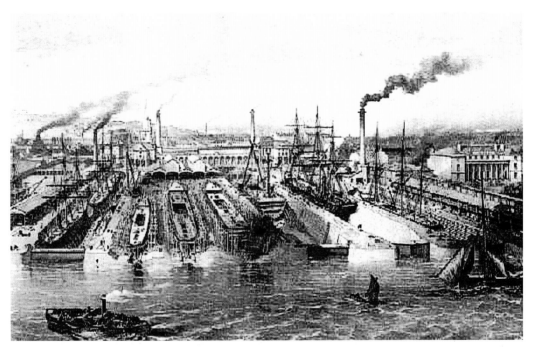

Laird's shipyard in the nineteenth century. (Courtesy of Liverpool Athenaeum Library)

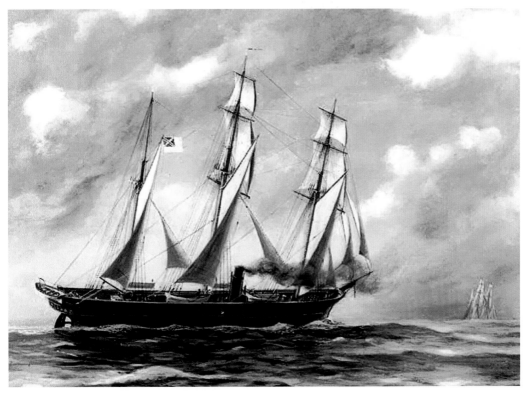

CSS *Alabama*, built by Laird's for the American Confederacy. (Discover Liverpool Library)

The first part of this triangular voyage was the shipment to the coast of West Africa of goods used for barter. These were packed into the capacious holds of specifically designed and equipped ships, anchored at Liverpool's quaysides. These goods came from all over Britain, and included muskets and pistols from Scotland; cutlasses, knives and axes from Sheffield; pottery and earthenware from Stoke and Staffordshire; cheap jewellery from Lancashire; cotton and linen from Manchester; woollen goods from Leeds and Bradford; and mirrors and glassware from St Helens.

In West African ports the laden ships were met by Arab and African slave traders. The bartered goods were then exchanged for African men, women and children who had been brutally abducted from their homes. These terrified people were generally kept naked and roped together at the neck or wrists from the time of their capture, and would often have already been marched hundreds of miles to the coast. They were then shackled together in the now empty holds of the same Liverpool ships, and transported to American and Caribbean plantations. This was the notorious 'Middle Passage' across the Atlantic Ocean, a journey that could take up to fifty or sixty days, often in appalling weather conditions. This was the second and most horrific leg of the Triangular Trade.

The third section was the shipping back to Liverpool, from the plantations and in the holds of the same ships, a cargo of cotton, tobacco and sugarcane that the slaves had been forced to plant, pick and pack.

Although an early slaving voyage from Liverpool was made in August 1700 by the *Blessing*, the first officially recorded slaving ship to set sail from the port was *The Liverpool Merchant*, which, later that same year, sold a cargo of 220 slaves in Barbados. Then, from 1737, Liverpool began to seriously increase its involvement in slavery. In 1771 alone, 105 ships sailed from

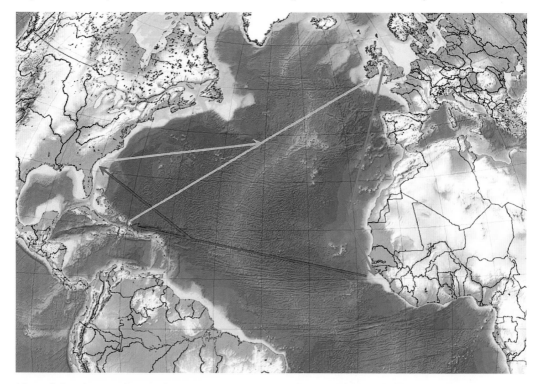

Map of the slave trade, which became known as the 'Triangular Trade'. (Discover Liverpool Library)

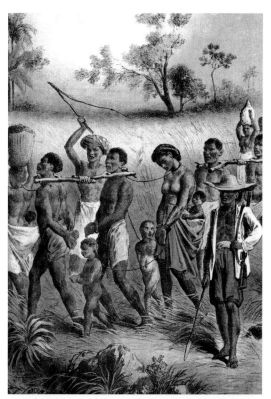

Right: Caravan of captives being walked to the African coast. (Discover Liverpool Library)

Below: The *Liverpool Merchant* slave ship. (Discover Liverpool Library)

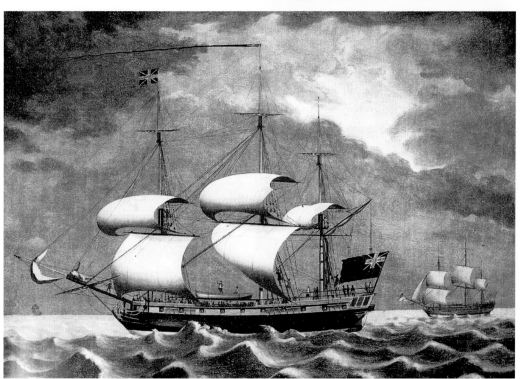

Liverpool to West Africa, and from there transported 28,200 slaves to the West Indies. During each voyage across the Middle Passage the sexes and ages of the captives were often randomly mixed. They were packed tightly together on hard wooden shelves, and were manacled and chained with no room to move.

Afflicted by seasickness, dysentery, humiliation, despair and terror, and with nowhere to relieve themselves other than where they lay, the decks and holds would be awash with excrement, urine and vomit. The conditions were foul beyond belief and slave ships stank so much that even on the high seas other vessels would steer clear of them.

In an attempt to minimise the death rate and maximise profits, and if the weather was calm, every few days the slaves would be brought up on deck to be washed, fed and exercised. They were still chained together, to prevent them from jumping overboard, which many of them attempted. Generally fed only on thin gruel, sometimes they were given a watery broth made of dried shrimps mixed with flour and palm oil, seasoned with salt.

Around 20 per cent of all slaves died on the Middle Passage, and only 6 per cent of those who did make land survived for more than a year in captivity. Of these, most only lived into their early 30s.

During the town's involvement in the trade, Liverpool-owned slave ships transported 1,360,000 African people in over 5,000 voyages. More than half of all slaves sold by English traders were the property of Liverpool merchants and by the end of the eighteenth century the town had 70 per cent of Britain's total trade in slaves.

In 1757, the first ever recorded cotton auction in Liverpool took place. This was held on the quayside, alongside the sailing ships as they unloaded their precious cargo. From this time

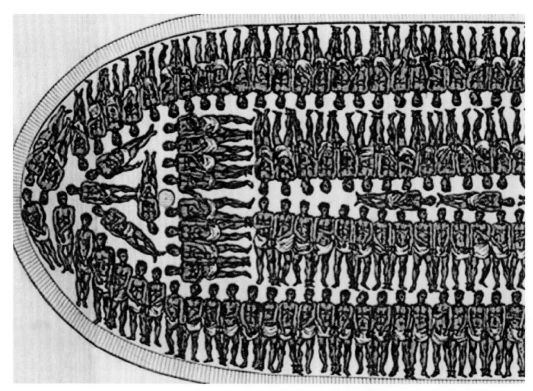

Slaves packed together in the slave ship's holds. (Discover Liverpool Library)

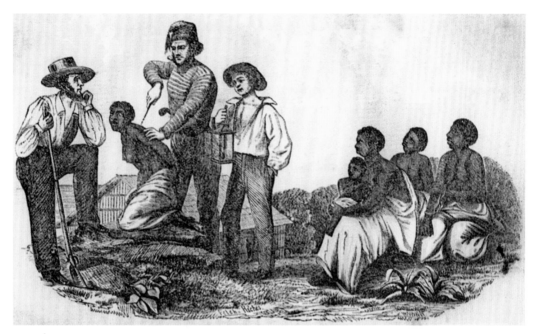

Slaves being branded with their owner's mark, on the plantation. (Discover Liverpool Library)

onwards the quantity of cotton imports coming through the port progressively increased. Indeed, by 1795 Liverpool was receiving the bulk of the 17,000 bales that were being imported annually into Britain.

To begin with most cotton was coming in from the West Indies and America but, from 1810, crops from other countries, such as India and Brazil, were becoming available for trade on the Liverpool cotton market. By 1850, cotton accounted for almost half of the city's trade, and over 1½ million bales were imported into the town every year.

Liverpool's involvement with slavery continued throughout the eighteenth century. Then, in 1787, a national petition for the suppression of the slave trade was handed to Parliament by some members of the Society of Friends (Quakers). This had been signed by many wealthy and influential people from Liverpool, including the highly respected merchant, scholar, and radical reformer, William Roscoe (1753–1831).

Eventually, and despite protectionism and downright ignorance from vested commercial and political interests throughout Britain, in 1807 an Act for the Abolition of The Transatlantic Slave Trade was carried through Parliament. This outlawed the transportation of slaves by British ships. Thus began the end of the Triangular Trade, which was finally stopped by the Slavery Abolition Act of 1833.

Following abolition, and despite the loss of this highly lucrative source of revenue, the port of Liverpool and its maritime trade continued to thrive, thanks to families such as the Rathbones, Holts, Rankins, and Bibbys, who were a new breed of entrepreneurial ship-owners trading in a variety of goods other than human beings. Such prominent individuals laid the foundation for Liverpool's massive expansion and more wholesome economic success during the nineteenth century.

Business was booming and Victorian Liverpool was getting three slices of the very large commercial cake: not only was the town importing raw cotton but it also shipped it all around the country. Then the finished products came back through Liverpool to be exported around

William Roscoe, Liverpool's most passionate and effective slavery abolitionist. (Courtesy of Liverpool Athenaeum Library)

the globe, and so the town made even more money. In fact, in 1901, almost half of the total exports from Liverpool originated in the Lancashire cotton mills, and it was in the years before the First World War that the cotton trade in Liverpool reached its peak.

As well as at the quaysides, trading in goods and commodities had also been conducted in and around the Town Hall of Liverpool, since the first such building had been donated to the town in 1515 by John Crosse (c.1464–c.1517). Originally called 'The Exchange', this building was in full use until 1674, when a brand new 'Town Hall and Exchange' building was ordered by the Corporation. However, by 1740 this was in a dangerous state and was beginning to collapse. As a result, the trading moved out of the building to the land behind.

When, in 1754, the current Town Hall was erected, the merchants continued to trade outside. By 1808 the area behind the Town Hall had been paved and was being referred to as 'Exchange Flags', and the increasing numbers of cotton traders continued to conduct business here. However, offices, meeting rooms, and other facilities were needed. So, in the same year, a magnificent new Cotton Exchange Building was constructed around the three sides of the paved area. Even so, cotton brokers still preferred to conduct their business in the open square, as this gave instant access to fellow traders, to exchange their news and information as well as to conduct business. This was before the days of the telephone and email of course! This open space continued to act as the Cotton Market for almost 100 years.

Business continued to thrive, but this meant that the trade and those involved in it required regulating, monitoring and resourcing, and so the 'The Liverpool Cotton Brokers Association' was formed in 1841. In due course, brokers and merchants realised that they had interests in common, and so they combined and formed a new organisation, 'The Liverpool Cotton Association', in 1882.

Now it became essential for the market to move indoors, as conducting business in the open-air was too slow and increasingly inefficient; and so the present Cotton Exchange Building in Old Hall Street was built. This opened in 1906 and its facilities were state-of-the-art: as well as telephones, the building showcased electric lifts, synchronised electric clocks, and direct cables to other cotton exchanges in New York, Bremen, and Bombay.

Throughout the early decades of the twentieth century, Liverpool consolidated its position as the cotton trading centre of the world, a position that it retains. However, during the Second World War the government took control of the trade. It was not returned to the Liverpool Cotton Association and the free market until some years later. Also, the building on Old Hall Street was badly damaged by Nazi bombs, but this was restored and, in 1954, the Earl of Derby officially reopened the Liverpool Cotton Exchange.

Today, Liverpool remains at the very centre of the cotton community and, in 2004, the Liverpool Cotton Association was renamed 'The International Cotton Association'. This now operates from offices on Exchange Flags once more.

Despite the fact that the cotton trade, and therefore the wealth of Liverpool, was built using the blood, sweat, and tears of enslaved humanity, it is important to recognise that the ultimate abolition of the slave trade was also driven from Liverpool, and by Liverpool merchants and shipping line owners. Also (and not built on the proceeds of slavery) the Liverpool Cotton Association played a crucial role in the development of the great city of Liverpool. It was responsible for constructing many city buildings of architectural significance and beauty.

Apart from slavery, the cotton trade in Liverpool fuelled the development of many other trades and professions, not least across the shipping industry. These included dock labour, warehousing, inland transportation by horse-drawn carts, canals and railways, provision merchants, maintenance companies, insurers, clerking organisations, solicitors, messenger companies, and many more. Thousands of people were employed in the mills, producing

Victorian cotton traders on Exchange Flags. (Discover Liverpool Library)

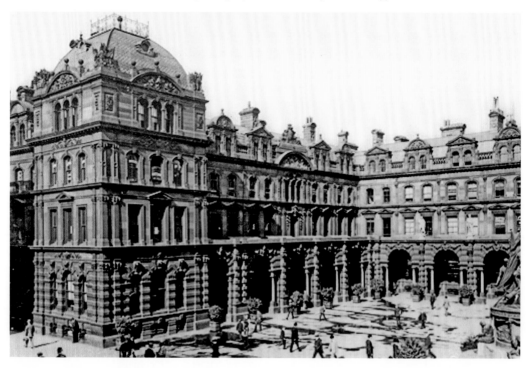

The original Cotton Exchange buildings surrounding Exchange Flags behind Liverpool Town Hall. (Courtesy of City of Liverpool Record Office)

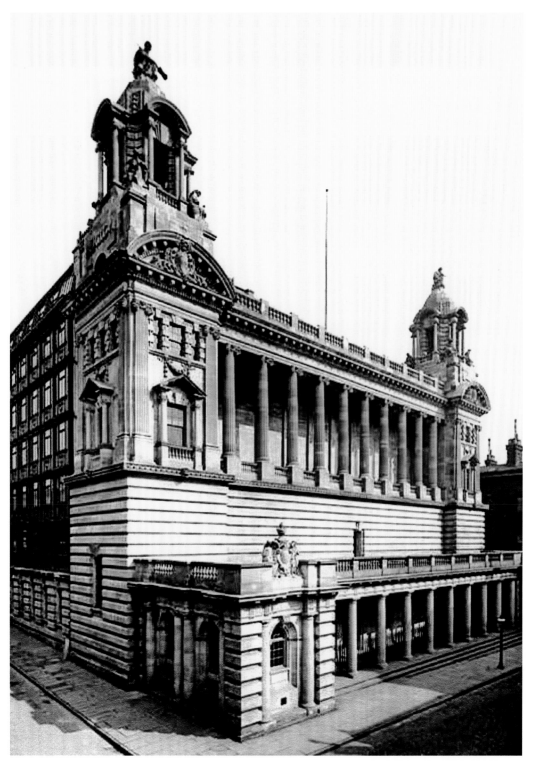

Twentieth-century Cotton Exchange on Old Hall Street. (Discover Liverpool Library)

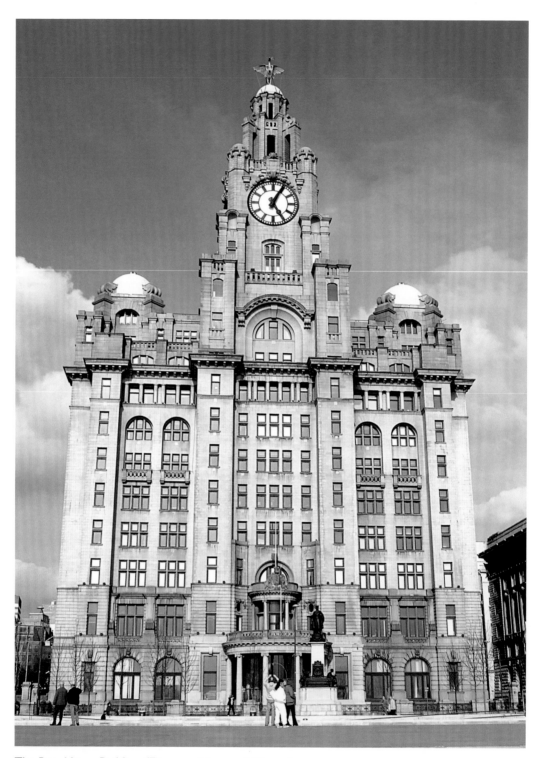

The Royal Liver Building. (Discover Liverpool Library)

cotton fibre and fabrics, and in the trades and professions that converted these into products and then sold them on.

Without the significant role that cotton played in the economy of the city, Liverpool would not have become the commercial giant that was to dominate British trade around the world for over 250 years. Indeed, there is a popular story that cotton bales were used as part of the foundations of the Royal Liver Building. This is probably no more than a myth, but it shows how important cotton is to Liverpool's history, and the Cotton Exchange building, now Grade II listed, has been at the core of this for 100 years.

Cotton and wool warehouse in Great Howard Street, 1919. (Courtesy of Liverpool Athenaeum Library)

CONNECTING ACROSS BRITAIN

Of course, as Liverpool began to connect and trade with countries around the world, so it connected with the rest of Britain. As early as the end of the seventeenth century increasing amounts of raw materials of all kinds, as well as wide ranges of manufactured goods, were now being brought in and out of Liverpool by track and road. This was preferable to transporting these by sea, as it was less hazardous, even though the quality of the roads in those days was extremely poor.

Until the beginning of the eighteenth century, most of Britain's roads were still no more than basic packhorse or cart tracks, created over centuries of common use, and beaten flat by foot, hoof and wheel. Roads could rapidly become rutted through overuse, overgrown because of irregular use, potholed due to inadequate maintenance, or completely flooded or washed away in bad weather.

However, and as ever, commercial pressures created change. As the need to travel and to move goods further afield increased, the improvement of key routes became an urgent priority. The most important road out of Liverpool was the packhorse road from nearby Prescot to the town. This was primarily used for the movement of coal. As this became busier, and as other routes began to make their way out of town, something had to be done to enforce road maintenance and security.

In 1725, a wet summer bogged down many of the coal carts and brought things to a head. So in 1726 an Act of Parliament created the Liverpool to Prescot Turnpike Road. This is now the modern A57.

'Turnpiked' meant that tollbooths, tollgates or tollhouses were placed every few miles along principal packhorse or coaching routes to raise income to pay for their regular maintenance. The word 'turnpike' was originally the name given to a gate-like frame, pivoting at one end on an upright post or 'pike', which blocked the route until the toll was paid.

Such tolls were payable in addition to whatever other fares or costs were charged for any journey, and were levied on demand at the tollgates. This was now another growing source of employment, as these tollgates had to be manned by toll keepers, who were called 'pikemen'. The pay for these men (and sometimes women) was poor, but they and their families normally lived rent-free in purpose-built toll cottages.

By 1761, the new Liverpool to Prescot 'highway' was extended further to then connect with other major routes. Coaches were soon also carrying the mail, goods and news to and from Liverpool and Manchester, and also between the town and the Midlands and London. With the development of this delivery service, people too began to travel on the coaches between Liverpool and the local towns.

Packhorses, the first commercial transport system serving Liverpool. (Discover Liverpool Library)

The wealthy travellers of the period, particularly those that lived in the great houses that the mail-coaches passed en route, were picked up at their gates. They were forewarned of the arrival of the coach by the driver, who blew through a long horn to herald their approach; hence a 'post horn'. These larger coaches travelled between the tollgates and major stops on a route in stages, hence their name.

As well as the workers who maintained the turnpike roads, and the pikemen, the expansion of stagecoach services saw increasing employment for coach builders, tavern keepers, serving wenches, stable boys, and blacksmiths.

In and around the taverns, inns and turnpikes was an increasing number of itinerant musicians and players who entertained waiting travellers. Also required, of course, were coach drivers and guards, so turnpike roads and the stagecoaches provided a great deal of skilled and unskilled work for many people.

By the mid-eighteenth century the amount of goods and people being transported by road grew rapidly as demand increased, and as the turnpike system ensured that road quality and security improved. However, this was still not enough for the commercial needs of Liverpool, and additional methods of inland transportation had to be devised. This too would generate a new source of employment, as well as creating an entirely new kind of community, the development of existing inland waterways.

The more important rivers were made navigable for moving goods by deepening them, so that they could accommodate barges and narrowboats with large holds. These were often linked together in water-borne trains, and barges were first horse-drawn by ropes, using towpaths alongside the waterway. In 1720, long stretches of the rivers Mersey and Irwell were deepened for this purpose. It was after this that specially dug canal waterways were created, and these revolutionised the bulk movement of commodities and of manufactured goods throughout the country.

A Liverpool mail and passenger stagecoach. (Discover Liverpool Library)

The businessmen and entrepreneurs of Liverpool quickly recognised the importance of canals, and their exploitation of this revolutionary method of transportation began with the opening of the Sankey Brook Navigation in 1757. This had been constructed to carry barges of coal from the St Helens coalfields to connect with the River Mersey and then on to Liverpool, and was the first man-made canal in England and the first commercial canal in the world.

This waterway, and all the subsequent ones that were soon being dug across the rapidly developing industrial landscape of Britain, were excavated solely by hand. The shifting of tons of earth using only spades, picks, shovels and muscle power demanded a new breed of manual worker. Because of their jobs on what were referred to as 'navigations', these burly men became known as 'Navvies'. Thousands of men were employed on these major civil engineering projects, and their wages fed themselves and their families and supported growing labouring communities.

Britain's first true canal, rather than a river navigation, was opened in 1761 as a business venture by Francis Egerton, 3rd Duke of Bridgewater (1736–1803). Named by him as the Bridgewater Canal, this is 39 miles (63 km) long and connects Runcorn with Leigh. Then came the building of what is still the longest canal in Britain, the 127¼-mile-long (204 km) Leeds–Liverpool Canal. This gave the impetus for the construction of other major canal systems around Britain, including the Trent and Mersey Canal, which is 93½ miles long (150½ kms) and connects the Trent and Mersey rivers. This opened in 1777.

All kinds of commodities and raw materials were carried by barges, one of the most important of which was animal and human manure. The growing town of Liverpool produced increasing amounts of waste that was removed along the canals, including street sweepings,

Sankey Canal today, now used for leisure rather than industrial purposes. (Discover Liverpool Library)

Leeds–Liverpool Canal. (Discover Liverpool Library)

household refuse, and 'night soil'. This latter was human excrement scraped out of lavatories and cesspits in streets, tenements, and courts, or piled into mounds or 'middens' in the streets.

As there were very few sewers, and the amount of such waste was always accumulating, this was a major health hazard. As a result, the Leeds–Liverpool Canal became a 'hygiene highway', regularly carrying manure that was spread on the fields around Litherland, Crosby, Formby, Freshfields, and Sefton. This helped to produce the extremely fertile farming land that is still found to the north of Liverpool.

In the mid-nineteenth century, 4,000 tons of refuse were transported weekly along the canal, with an additional 3,000 tons of nightsoil. Although this type of canal traffic declined with the building of sewerage systems across Liverpool, the carrying of manure continued until the 1940s.

Factories, warehouses, wharves, and quays soon developed at strategic points alongside these canals, as did barge repair workshops, stables for the horses, and new communities of water folk; the 'bargees' and their families. These people took a real pride in their skills as watermen, and in their vessels, giving their barges romantic or evocative names as well as painting and decorating them, and their equipment, with beautifully executed designs in vivid colours.

Well into the twentieth century the canals in and around Liverpool created and supported tens of thousands of jobs. These were in all kinds of manufacturing and transportation industries, as well as in their satellite businesses and supply chains.

The Industrial Revolution of the late eighteenth and early nineteenth centuries irrevocably changed the face of Britain and, in particular, how raw materials, goods and people were

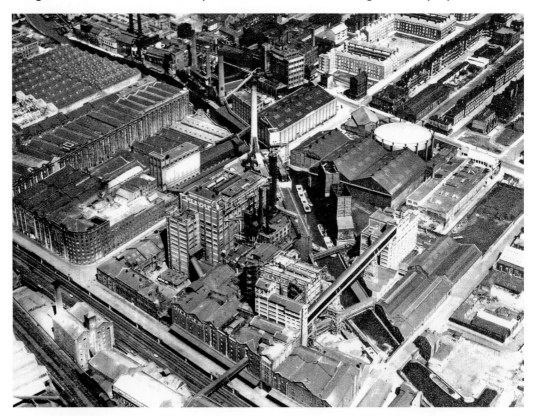

The Tate & Lyle sugar refinery straddling the Leeds–Liverpool Canal. (Courtesy of Liverpool Athenaeum Library)

transported. Once again it was the pioneering town of Liverpool that led this, and particularly with the coming of the railway.

There were already a number of railway lines in Britain by the early decades of the nineteenth century, but these were mostly for industrial purposes, such as hauling coal and other goods over short distances in collieries. However, all this changed when, in 1826, the great engineer George Stephenson (1781–1848) was invited to visit by certain wealthy and prominent businessmen from Liverpool and nearby Manchester.

These men were the Directors of the Liverpool and Manchester Railway Company (L&MR), and they proposed to build a railway to provide faster transport of raw materials and finished goods, as well as passengers (although this was an afterthought), between the port of Liverpool and the cotton mills and factories of Manchester.

Road and canal transport were no longer adequate for the ambitions of these men, in this modern age, and they also felt that a railway would be cheaper to run and more profitable for its owners and investors. Trains of wagons on this new link between the two great northern cities would be drawn by some form of mechanical means and the L&MR Company hired George Stephenson for the project. He set to work immediately.

The line consisted of two parallel tracks covering a distance of 35 miles, which had to be laid over some very difficult terrain, including across the treacherous and broad Chat Moss. This was not the only significant engineering problem that Stephenson had to overcome. The line began with a goods depot at Wapping Dock in Liverpool, and then travelled through a 2,250-yard tunnel beneath the town to Crown Street Station at Edge Hill. It was here that passengers boarded trains to and from Manchester. From the station the line then ran through a 2-mile cutting running through solid sandstone bedrock and which, at Olive Mount in Wavertree, was almost 70 feet deep.

Then a viaduct had to be built over the Sankey Brook Valley, supported by nine 50-feet-wide arches, each around 70 feet high. Numerous massive embankments and other cuttings also

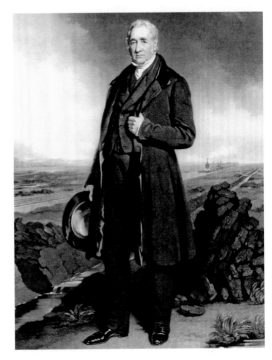

George Stephenson, the great engineer and railway pioneer. (Discover Liverpool Library)

The Olive Mount cutting. (Discover Liverpool Library)

had to be constructed along the route. All of these magnificent feats of civil engineering were again carried out using only muscle power, by Stephenson's labourers, who were still known as 'Navvies' as many of these men had already dug many of Britain's canals.

In 1828, the Railway Directors could not agree on how to power their new transportation system, and so they decided to hold a competitive series of railway trials to choose the most effective locomotive. These had to take place quickly as work on the tracks was now well underway. And so, beginning on 8 October 1829, at Rainhill just outside Liverpool, a number of steam locomotives competed against each other, not just for the contract but for a prize of £500.

While George Stephenson was largely occupied in supervising the building of the railway line, he had every intention of winning the competition, and of using *his* locomotive on *his* railway tracks. Consequently his son, Robert (1803–1859), who was then only 24 years of age, concentrated on developing the locomotive that would be the family entry for the competition. This he named the *Rocket*, which was one of five competing locomotives.

George and Robert Stephenson won the rigorous trials in grand style, having attached a coach to their engine containing thirty passengers. They impressed the judges, the spectators, and no doubt their passengers, by travelling at the seemingly impossible speed of between 24 and 30 mph! At the conclusion of the trials, *Rocket* was the only locomotive to have completed the course, and so was declared the outright winner: the prize was duly awarded to the Stephensons. A year later the rail link had been completed, and 15 September 1830 was the date of the inaugural run between Liverpool and Manchester.

This was the first railway to carry passengers and goods on a regular basis, and to a timetable. It was also the first inter-city passenger railway in the world. This service proved immensely popular and was soon transporting over 2,000 people each day. In the first year of operation the railway also carried over 40,000 tons of goods and, by 1835, this had increased more than five times. In the same period, the amount of coal that was carried by rail increased from 11,000 tons to 116,000 tons.

As with every other major innovation and development in Liverpool, the railways created an entirely new workforce of skilled and unskilled people. The supporting trades and supply

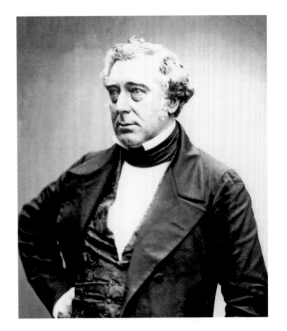

Right: Robert Stephenson. (Discover Liverpool Library)

Below: The steam locomotive *Rocket*. (Discover Liverpool Library)

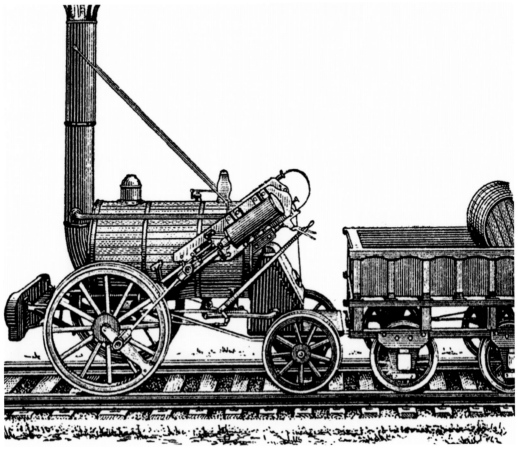

chains for the railways also created more employment opportunities and so the population numbers of the town increased yet again.

Rail travel changed the face of the country, the British Empire, and the world. However, despite the impact of steam power, in Liverpool there remained a major source of motive power upon which the economy of the town, and the employment of its people, truly depended.

Before the invention and development of the internal combustion engine, as the nineteenth became the twentieth century there had been only one, reliable, powerful form of motive power that was widely and readily available: horses. From the beginning of recorded time people had ridden horses and used them to plough their fields. As civilisations and societies evolved, and as people needed to move themselves and their goods from place to place, it was horses that carried them and their packs. As we have seen, in due course they were drawing carts, carriages, stagecoaches and wagons, and hauling canal barges. For a time they would also draw fire engines and ambulances, as well as trams and omnibuses. Now they became a vital part of Liverpool's industrial and commercial infrastructure.

Liverpool had the reputation for producing and utilising the biggest, strongest and most loyal, steadfast and resolute carthorses in Britain. They were well cared for and, as we have seen, their manure fertilised the land surrounding the town. The crops this produced fed the horses and the people in return.

Liverpool is built on seven main hills and many smaller rises. To enable the animals to gain and sustain traction on the streets and roadways, as well as on the quaysides, Liverpool Corporation and The Mersey Docks and Harbour Company laid and maintained millions of cobblestones. These were for horseshoes that saw so much heavy work that they had to be changed every three to six weeks.

The use of 'horse power' in this way increased in places like Liverpool as its commercial interests and population grew. This reached a peak during the Victorian and Edwardian eras,

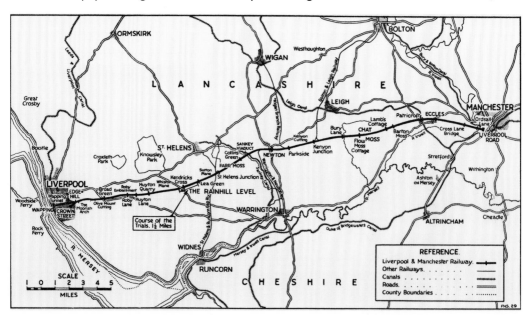

The route of the world's first intercity passenger railway from 1830. (Discover Liverpool Library)

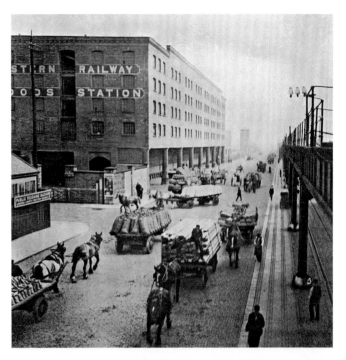

Right: Horse-drawn vehicles on Liverpool's cobbled dockside roadway at the turn of the twentieth century. (Courtesy of Liverpool Athenaeum Library)

Below: There was a great bond of mutual respect and love between carters and their animals. (Courtesy of City of Liverpool Record Office)

when more than 20,000 horses were working on the streets of the port and in its suburbs and surrounding districts on both sides of the Mersey.

Since the opening of the Old Dock, and for over 250 years, horse-drawn carts and wagons crowded the streets, docks, wharves, warehouses, quay and canalsides. They jostled for space among the throngs of dockers, labourers, trades people, sailors and pedestrians in the noise, dirt, soot, and smoke of the thriving metropolis.

They did so in declining but still significant numbers into the 1950s and '60s when, throughout my own childhood, I remember that most bread, milk, and coal deliveries were from horse-drawn floats. The rag-and-bone men, the corporation refuse wagons, the knife grinders, and chimney sweeps serviced the public from horse-drawn vehicles. I can recall the clip-clopping of the hooves, the rattling of the carts, floats, and traps, the clanging of the metal-rimmed cartwheels, and the neighing and snorting of those magnificent animals.

On 1 May 2010, on the anniversary of the great annual horse parades that once took place in the city, a special ceremony took place. This was held at Mann Island, near the Pier Head, in front of crowds of people, the press, and civic dignitaries. After the speeches an 8-feet-high bronze sculpture of a magnificent cart horse was unveiled. Showing the animal ready to be harnessed to his next load, the artwork is named 'Waiting'.

The men, and also many women, who worked these horses, and who fed, stabled, and cared for them were known as 'carters'. This was yet another sub-community and subculture within the wider population of Liverpool. Together with the blacksmiths, farriers, harness-makers, and cart builders, these workers and their wonderful horses played a glorious role in the life of the great city.

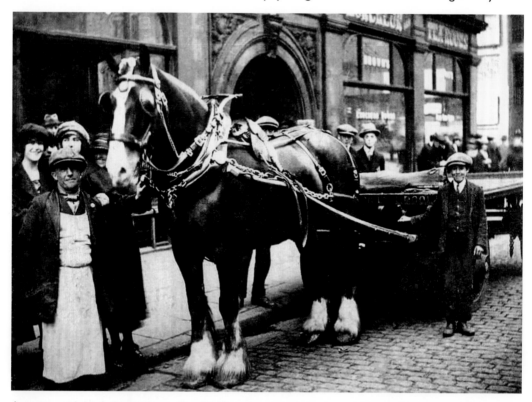

A carter with his lad stand proudly with their horse and cart on a Liverpool city street in the 1930s. (Courtesy of Liverpool Athenaeum Library)

UNEMPLOYMENT AND UNREST IN LIVERPOOL

The rise of Liverpool continued throughout the nineteenth century, and the town's civic pride and material wealth became apparent in its glorious architecture. In the entire British Empire it was second only to London in economic power and commercial significance. This culminated, in 1880, with Liverpool being awarded city status by Queen Victoria (1819–1901): it had reached its zenith as the Victorian era became the Edwardian.

However, the twentieth century was to be one of change and challenge for Liverpool and unlike any previous century in its complex history. This began with the First World War (1914–1918), when Liverpool and Merseyside suffered thousands of deaths and serious casualties as its young men fought on foreign battlefields.

While the city was to experience continuing economic growth in the 1920s, by the 1930s many of its people were suffering great poverty and hunger in the Great Depression. In fact, during this period the number of those out of work in Liverpool stood at twice the national average. In an attempt to create jobs the government offered incentives to employers to encourage them to set up at what would be Britain's first purpose-built municipal industrial estate. This opened in 1936, in Speke at the southern end of the city, for chemical and pharmaceuticals manufacture, and light engineering. However, this had only a limited impact on unemployment numbers.

On Liverpool's docks the population seeking jobs was ever-increasing, so work in the port was often unpredictable and largely on a casual basis. At their peak of operation, Liverpool's docks had once regularly employed 25,000 dockers, and were a hive of day and night-time activity along their full 7½-mile length. There were times when over 100 vessels at once were moored in the port, which is why the Liverpool dockers had been so vital to the life of the Mersey. However, between the wars the supply of dock labour also seriously exceeded demand.

Then, the Second World War (1939–1945) saw Liverpool become the most heavily bombed city in Britain outside London (although some historians now believe that the sheer tonnage of high-explosive and incendiary bombs dropped on the city was greater even than that dropped on the capital). After the war Liverpool sought to redesign and rebuild itself, but with only limited success. The city also experienced an all-too-brief economic boom in the late 1940s and early '50s, which was the last time that Liverpool saw almost full employment.

By the beginning of the 1960s, though, it was becoming clear to city leaders and businesspeople that all was not well. The River Mersey and the seas of the world had been the source of Liverpool's success and wealth, but now changes in international maritime trade were about to fuel the

Left: First World War propaganda and recruitment poster. (Discover Liverpool Library)

Below: Men queuing for work on Liverpool's docks. (Courtesy of City of Liverpool Record Office)

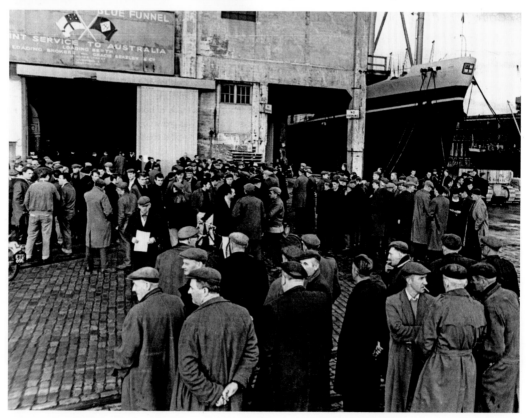

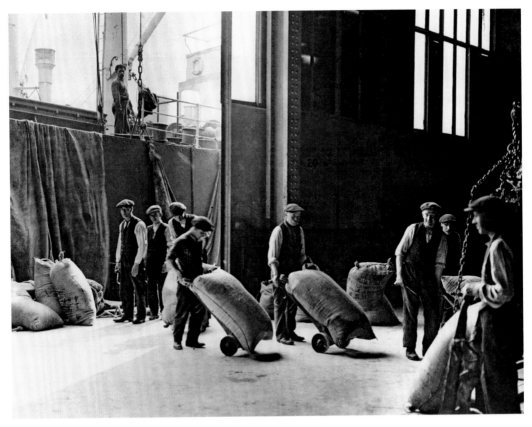

Dockers at work. (Courtesy of City of Liverpool Record Office)

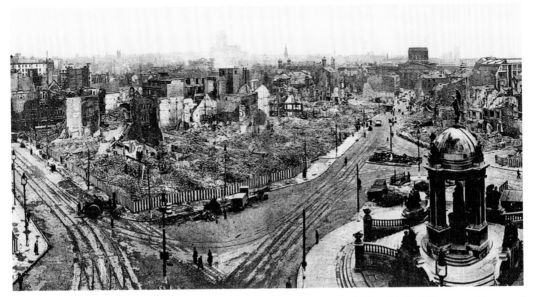

The devastated city centre of Liverpool after the Blitz of May 1941. (Discover Liverpool Library)

collapse of the city and the mass unemployment of its people. This would also lead to massive population decline and shattering social breakdown.

The world economy was shifting and Britain was losing its dominant place of power in the world. Whereas Liverpool had been in an advantageous position geographically, facing onto the Atlantic Ocean and towards the New World, after the war this was no longer the case. Now Britain and its former wartime allies were concentrating on rebuilding war-torn Europe, and Liverpool was on the opposite side of the country and facing the wrong way entirely.

As well as this, the countries of the British Empire were gaining independence and many were now trading elsewhere. Also, most people travelling overseas were now doing so by air, and sea-borne cargoes were being shipped in bulk containers. On the docks these were handled and transported mechanically and so Liverpool's dockers quickly became 'surplus to requirements'.

Even though the port authority, the Mersey Docks and Harbour Board (MDHC), responded as quickly as it could and began to build the massive container-handling terminal that still dominates Liverpool's north docks at Seaforth, many shipping lines had already begun using other ports. However, the main problem for the working people of the port was that the new containers made the need for manual labour largely unnecessary.

By the late 1960s many of the docks on both sides of the river were either in rapid decline or already derelict, and these sources of Liverpool's past prosperity were now symbols of its economic collapse. By the end of that decade, Liverpool's time as one of the world's most successful ports was over, at least in its old form. Because Liverpool's economy and commercial structures were so tied in to the maritime industry, the knock-on effect of its decline was enormous. Supply companies to shipping lines also failed and closed. These included insurers and brokers of all sizes, as well as a vast array of manufacturing, provisioning, haulage and servicing companies. Now both white-collar and blue-collar workers swelled the ranks of Merseyside's unemployed.

Three decades after the Depression, and in an attempt to address yet another developing employment crisis, Liverpool City Council, with some government backing, offered lucrative incentives to a wide range of large employers to set up factories in the city. These were located at new industrial estates serving the equally new post-1960s slum clearance overspill towns, such as Kirkby and Skelmersdale. They also built factories to provide jobs for communities of people displaced by wartime bombing. These were moved to outlying districts of Liverpool, like Aintree, Speke, Huyton, and Halewood.

Over the centuries the principal activity of Liverpool's workers had simply been to move things around. They had loaded, unloaded, carried, and transported commodities and goods from one place to another, which are occupations that require very little skill. These new employers included Lockheed, Lucas, Metal Box, Dunlop's, and motor car manufacturers Standard Triumph and the Ford Motor Company. However, while some of employers required a skilled workforce, most relied on production line manufacturing processes.

Local and national government had invited them to Liverpool because they felt it would be cheaper and less complex to just replace one set of menial occupations with similar ones. This was even though local workers were both willing and eager to be in full-time, fairly paid jobs, and were equally willing to be retrained and up-skilled. The people of Liverpool had made billions of pounds for Britain and her Empire for hundreds of years, but the short-sightedness of politicians, of all parties, was now failing them.

Government also failed to recognise and accommodate the proud independence of Liverpudlians that had always driven the city to greatness. The management teams running the companies then setting up around the city also made the same mistake. Instead of engaging with, consulting, sharing, involving and inspiring their workforces, which is how any business

succeeds, they simply ordered their employees to comply with outdated managerial practices and often inadequate working conditions and pay levels.

As a result, the workers felt disrespected and underrated, which is something that particularly irks Liverpudlians, and so their response was predictable. Soon industrial unrest and strikes became endemic across these newer industries. This further fuelled the economic decline and social collapse, as many companies simply closed up and moved away, rather than invest in developing their management skills and labour relations.

Because of increasing unemployment on the docks these workers too began to strike. This was in a vain attempt to improve their security, pay, and conditions. All this action did, however, was cripple the port further, despite the legitimacy of their grievances. Dock workers and dock employers were equally intransigent, and this began to entrench government hostility towards the city and the region. Liverpool rapidly became an unemployment black spot.

In parallel with the downturn in employment, the population of Liverpool continued to fall dramatically. The city seemed doomed, so those with the means, or who had transferable skills, simply moved away to start again elsewhere. This was ironic, considering how Liverpool had begun.

From the pre-war peak of just under 900,000, by 1971 the number of people living within the city boundaries had fallen to 610,000. By 1981 the figure had reduced to a catastrophic 510,000. This meant that, whilst Liverpool had an infrastructure for almost 1,000,000 people, it did not have enough ratepayers or revenue streams to adequately fund this. The city was soon on the verge of bankruptcy.

All of this, together with the policies of the then Conservative government led by Prime Minister Margaret Thatcher (1925–2013), drove many people in Liverpool to desperation. Added to this was a complete breakdown in communication between Merseyside Police and the largely black and mixed-race communities of inner-city Liverpool. The Force was notorious for its insensitive and heavy-handed policing of such areas. Many people felt they were being

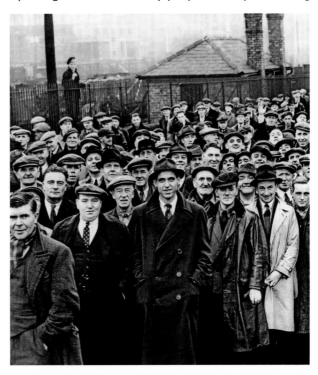

Workers strike meeting.
(Courtesy of City of Liverpool Record Office)

targeted simply because of their skin colour. The city became a powder keg of unrest and an explosion was inevitable. This came to a head on 3 July 1981, when some Merseyside police officers mishandled a minor incident in the Toxteth district of the city. This directly triggered – across that district and ultimately across Liverpool and parts of Merseyside – the worst public disturbances then seen on the British mainland since the English Civil Wars in the seventeenth century. What became known the world over as the 'Toxteth Riots' had begun.

Periodically throughout July and early August of that hot summer, large numbers of black, mixed race, and white people poured onto the streets with the specific intention of fighting the police. Full-blown battles took place between vast crowds of rioters and police officers from forces across the north of England. The major outbreaks of violence lasted a few days, and then they simply seemed to exhaust themselves. The police eventually regained control of the streets only when the rioters became bored and decided to go home. By the end of August the street violence had finally petered out and a pall of depression and frustration settled over Liverpool.

It is often mistakenly assumed that the riots were race riots, but this is absolutely not the case. The Toxteth Riots were a war: a conflict between a demoralised and desperate community, predominantly but not exclusively black, and a brutal policing strategy. The police also bore the brunt of anti-government feeling, because they represented Authority and the Establishment.

Throughout that summer many of the country's urban communities were in similar crisis, and there were outbreaks of street violence in forty other British towns and cities. In the words of Dr Martin Luther King (1929–1968), 'Riots are the language of the unheard.'

However, the violence in Liverpool was extreme and attracted intense, inevitably negative, worldwide media attention. For many years this gave the community of Toxteth and the people of Liverpool an undeserved reputation that further prejudiced the national view of the city. The economic collapse of Liverpool at this time, and its rapid fall in population numbers and dramatic rise in unemployment, had a profound effect on all its communities, regardless of race.

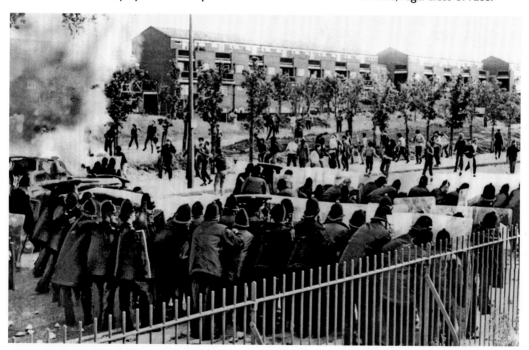

Toxteth Riots in the summer of 1981. (Courtesy of City of the *Liverpool Echo*)

Just a couple of months before the outbreak of the riots, the Merseyside County Association of Trades Councils had decided to organise a protest march to London. With national support from the TUC and named 'The People's March For Jobs' this set off from Liverpool on 1 May 1981. The march began with 280 people but thousands more joined along the route. It ended in London, on 31 May, with a rally in Hyde Park attended by 150,000 people. Sadly, the government failed to recognise or respond constructively to the marchers' grievances. The People's March was repeated in 1983, but Margaret Thatcher again refused to meet with any of its representatives.

To add to the city's woes, in 1984 the Tate & Lyle sugar factory on the banks of the Leeds–Liverpool Canal closed its doors and decimated the economy of the local community. This was far from being the only major employer to go out of business. Between 1966 and 1977 around 350 factories in Liverpool either closed down completely or moved away, resulting in the loss of 40,000 jobs.

Between 1971 and 1985, employment in the city fell by 33 per cent and, in the year of the Toxteth Riots, 20 per cent of the working population was unemployed. There were only fifty jobs available for every 13,000 people registered as unemployed in Liverpool.

This increased the groundswell of working-class resentment in Liverpool and fuelled a strengthening of left-wing and union activism that only exacerbated a worsening political climate. In particular, and helping to shape the negative way the rest of Britain regarded Liverpool, were the policies and actions of its City Council, especially those of its Deputy Leader, Labour Councillor Derek Hatton (b. 1948).

Hatton was a prominent member of the extreme left-wing 'Militant Tendency' in Liverpool. This was a Trotskyist faction of the Labour Party that had won control of the council. Their political tunnel vision and partisan politics are often cited as being what administered the fatal, economic *coup de grâce* to Liverpool and Merseyside at the close of the twentieth century. This was a time when a thriving private sector was desperately needed to finance economic growth in Liverpool. However, while the economic decline of the city pre-dated the Hatton era, the ideology of the Militant Tendency actively deterred serious potential investors. In effect, Liverpool was 'closed for business'.

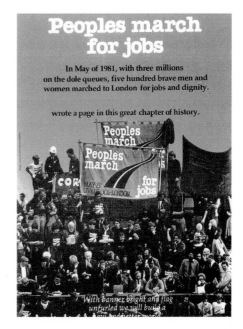

The People's March for Jobs in May 1981.
(Discover Liverpool Library)

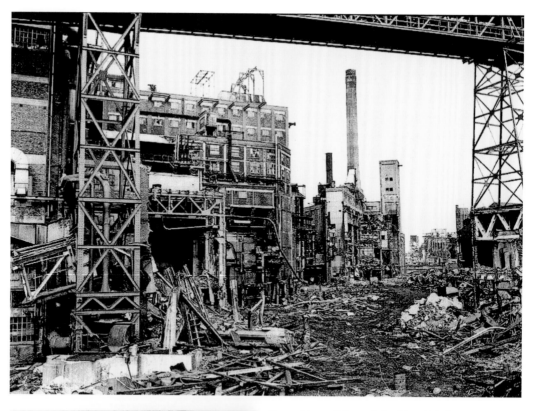

Above: Demolition of the Tate & Lyle factory. (Courtesy of Liverpool Athenaeum Library)

Left: Derek Hatton, the deputy leader of Liverpool City Council in the 1980s. (Discover Liverpool Library)

The economic reality was that the city needed some form of miracle if its degeneration was not to become terminal. What was then completely unknown, however, and certainly not just on the streets of Liverpool, was that the British government had already decided that the city should be deliberately left to die. Secret Cabinet discussions had been taking place within the Thatcher government immediately following the Toxteth Riots. The full extent and tone of these meetings were only revealed in 2011, with the release of previously confidential government papers under the Thirty-Year Rule.

Thatcher and her Conservative Party knew full well in 1981 that they were regarded in Liverpool as being indifferent to the industrial decline across Merseyside. The Prime Minister was convinced that the city, and its surrounding communities, was nothing more than a place of permanent industrial unrest, civil degeneration, political militancy, and terminal urban decay.

The Chancellor of the Exchequer at this time was Sir Geoffrey Howe (1926–2015). He believed that declining industries and communities such as in Liverpool should not be propped up but left to succumb to a process of inevitable attrition. Howe thought that to provide any form of economic or social resources to Liverpool would be a waste of money. Thatcher shared his view.

Whilst these Cabinet decisions were being taken the people of Liverpool were quickly becoming fed up with the lack of political vision and unimaginative leadership of their city. At council elections they demanded and forced a change of attitude in the City Council. In a powerful backlash against the legacy of Hatton's methods and policies, the city's new leaders, together with agencies and organisations from all sectors, began to forge new and effective social and commercial partnerships. They realised that this was the only way to halt Liverpool's otherwise inevitable downward spiral into bankruptcy and total collapse.

This new strength of purpose and focus laid a foundation upon which effective regeneration projects could be built. However, and despite Liverpool's total lack of faith in the government, what was to become the renaissance of the city would actually be driven by a member of the Thatcher Cabinet – a miracle was indeed about to take place.

Prime Minister Margaret Thatcher and her Chancellor of the Exchequer, Geoffrey Howe. (Discover Liverpool Library)

LIVERPOOL: THE WORLD IN ONE CITY

Not every member of Margaret Thatcher's Cabinet agreed with her plan to allow Liverpool to die; notably the then Secretary of State for the Environment, Michael Heseltine (b. 1933), now Lord Heseltine. He argued that such riot-hit communities should be actively regenerated, especially Liverpool and the rest of Merseyside.

During the Thatcher administration, Heseltine had always been a political thorn in the side of the Prime Minister, and a potential threat to her leadership. So when he suggested that he should go to Liverpool himself to see what could be done, she quite happily despatched the flamboyant and energetic MP to the North, on what she expected would be a fool's errand that would damage his career. However, soon becoming dubbed the unofficial 'Minister for Merseyside', Heseltine proved to be more than equal to the challenge. He knew that his absolute priority was to get Liverpool and Merseyside back to work as quickly as possible. He also knew that to do so he needed to revive the local economy using every asset that the city and its region had at their disposal.

Bringing in some experienced and trusted lieutenants of his own, but also harnessing the talents of committed and qualified local community, business and political leaders, he took oversight of the Merseyside Development Corporation (MDC).

The mission of the MDC, which had been set up early in 1981, was to 'secure, in partnership with others, advances towards self-sustaining regeneration on Merseyside', and it was to do so particularly by bringing 'life back to 865 acres of degenerated dockland on both banks of the Mersey'. Heseltine saw that this would be an ideal vehicle through which he could operate, by ensuring that the MDC's energies were directed where they were most need.

The Minister also established the Merseyside Task Force, which was made up of twelve top civil servants and twelve senior executives from large private sector companies. Government now began to direct significant levels of grant aid to Liverpool and the rest of Merseyside. The main objective of the Task Force was to spend this money on economic development and job creation. With Heseltine's guidance, but under the inspired leadership of top civil servant Eric Sorensen (b. 1943), this government QUANGO identified and successfully delivered thirty such initiatives.

New and existing employers were encouraged to provide appropriate in-house or supported training for new staff. This not only increased the company's skills base but opened up the job market to many more previously unskilled or differently skilled workers. These companies, together with their local suppliers, went on to create thousands of new jobs.

Michael Heseltine in Liverpool. (Discover Liverpool Library)

Nevertheless, Liverpool's economy was still very weak. Despite new employers coming into the region this was only beginning to dent the unemployment figures. Traditional manufacturers continued to close, with the loss of thousands of local jobs. As well as the closure of the Tate & Lyle sugar factory in 1984, in 1990 the closure of the British American Tobacco factory, also in the heart of the city, further undermined the local economy and increased unemployment, as would the closing of the Garston-based Bryant and May match factory, in 1994.

Regardless, the investment into Liverpool of funding and expertise continued to regenerate its economy. Michael Heseltine directed much of this money towards the assets he believed had the greatest potential; the docklands, warehouses and quaysides of Liverpool, especially the south and central docks. With imaginative plans and sufficient investment these could all be rebuilt and regenerated. He saw them as locations for new, small to medium businesses, especially those involved in the service, retail, hospitality, and tourism sectors. This visionary work began with the abandoned Albert Dock warehouses and the silted-up dock itself. In 1983, the MDC had set up the Albert Dock Company and work began immediately.

The first phase opened in 1984, and the project was completed in 1998. With its apartments and office accommodation, and vast range of leisure and cultural attractions, this helped to promote the city as a tourism centre. The Albert Dock complex is now the largest group of Grade I listed buildings in Britain, and one of the country's most visited tourist destinations. The

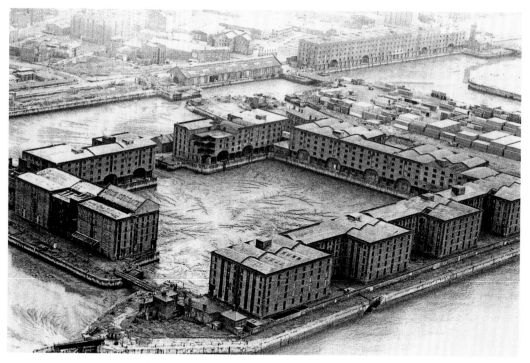

Silted-up Albert Dock. (Discover Liverpool Library)

continuing success of this project prompted further extensive redevelopment of Liverpool's docklands, turning them into a major international tourist destination, as well as the location of new homes and modern commerce.

Throughout the 1980s and the beginning of the 1990s, the regeneration process and the enterprise initiatives had a profoundly transformational impact across Liverpool and wider Merseyside. In Liverpool the civic leadership of the past had been replaced by local politicians who were eager to work in partnership with both the public and private sectors. The new breed of dedicated men and women who now made up Liverpool City Council were eager to continue to invest in the rescue and economic rebuilding of their city.

It was not only government agencies, politicians, and the private sector that were responsible for this progress; the ordinary people and their residents' associations, community groups, faith communities, and cultural organisations all played their part too. They also gave of their time, experience, and skills to make significant contributions to the process. Indeed, without the support and encouragement of the people of the region, Michael Heseltine and his teams would have made little headway. However, in 2012 Liverpool publicly acknowledged the key role that the former 'Minister for Merseyside' had played in its initial post-riot regeneration and rehabilitation by honouring Lord Heseltine with the Freedom of the City.

By the end of the 1980s Britain had entered yet another deep recession. Across the country this would see company earnings decline by 25 per cent, unemployment rise by 55 per cent, and mortgage interest rates reach a crippling 15.4 per cent. Thousands of people lost their homes, and hundreds of thousands more found themselves on the dole again. Naturally, and as if once again blighted by fate, Liverpool and Merseyside were among the regions that suffered most of all.

The Albert Dock complex today, one of Britain's most popular tourist attractions. (Discover Liverpool Library)

There still remained a legion of issues that urgently needed funding and imaginative solutions but, and to the surprise of many people, it was Liverpool's very poverty that was to be the cause of its deliverance. Ironically this would come from Europe, which, in so many ways, had been responsible for the city's initial post-war decline.

The start of Liverpool's resurgence, however, did not take place until 1994. The Merseyside economy at that time stood at less than 75 per cent of the European average, and so qualified the region for an initial tranche of European regeneration funding. In that year £700 million was received under the Objective 1 Programme and was matched by £700 million from the British government.

Then, in 1998, the European Parliament declared that Liverpool and Merseyside were actually poorer than Sicily! What, on the face of it, was a depressing announcement actually proved to be quite the opposite because in 2000 another £928 million of European money followed.

It was as if the city had been plugged into a particularly efficient life-support system that completely revitalised its regeneration. Work to turn around the economy of Liverpool and Merseyside could now continue with greater speed and effectiveness. In fact, between 2007 and 2013, the North West benefitted from a further £700 million injection of capital funding. It is accurate to state that without the vast levels of funding provided by the European Economic Community (later the European Union) Liverpool would have indeed died and become nothing but history.

As well as its docklands, Liverpool now recognised that it did indeed have some other major assets to develop and exploit. The most obvious of these were its association with art and popular music; its internationally renowned Football Clubs; and its magnificent architectural heritage, so much of which, fortunately, had survived or been rebuilt following Hitler's bombing raids.

Work on regenerating the economy of Liverpool, and on creating and sustaining employment for its people, continued as the twenty-first century dawned. Then an announcement was

made that undoubtedly helped to re-establish the self-confidence of Liverpudlians, and the confidence of the rest of the country, in Liverpool. On 4 June 2003, the government declared that Liverpool had been chosen as the nominated British city for the title of 'European Capital of Culture for 2008'. The jubilation throughout the city was passionately expressed. Then, in 2004, another major announcement was made when UNESCO declared that significant areas of the city of Liverpool, and its docks and waterfront, had been granted World Heritage Site status.

There are natural World Heritage Sites all over the world, such as the Grand Canyon and the Great Barrier Reef. There are also cultural sites, which include the Great Wall of China, the Taj Mahal in India and the Egyptian Pyramids. Whilst it may at first seem grandiose to consider Liverpool in the same light as these places, it is now recognised that modern sites as well as ancient ones have had a powerful impact on world events and history.

Consequently, Liverpool's dock buildings and waterfront architecture, its Georgian and Victorian buildings, its great cathedrals and much else, helped the city qualify for the prestigious title. Being both a European Capital of Culture and a World Heritage City now enabled Liverpool to fully reclaim its rightful world-class status.

Although the city and its region are still struggling to overcome the worst of the most recent national and international recession, Liverpool's global status means that the economy of the city continues to grow at an above average rate.

Other major redevelopment projects brought about directly by Liverpool winning its international accolades included a new terminal building for the world-famous Mersey ferries. This was opened at Liverpool's Pier Head in 2009, with a new landing stage for the vessels being opened in 2012.

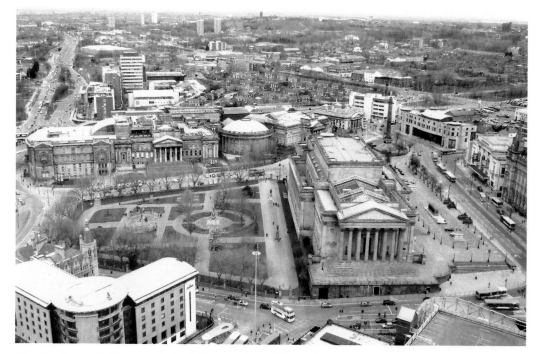

The St George's Quarter helped Liverpool qualify for World Heritage status. (Discover Liverpool Library)

The Liverpool Echo Arena opened in 2008 on the site of the former King's Dock, alongside the BT Convention Centre. These, together with the adjoining Exhibition Centre Liverpool, which opened in 2015, are among the most profitable and popular conference and entertainment venues in Europe. The most recent large museum to be built in Britain is the Museum of Liverpool, which also stands on the waterfront. This opened in 2011, and alongside it runs the latest canal to be cut in Britain, the extension to the Leeds–Liverpool Canal, which opened in 2009.

These visitor attractions and economic resources have created thousands of new jobs and business opportunities, as have Liverpool's many tourism and entertainment zones. These include the Baltic Triangle, Chinatown, the Football Quarter, the Gay Quarter, the St George's Quarter, and the Knowledge, Creative, Georgian, and Hope Street Quarters of the city; actually more 'quarters' than are geometrically possible!

Another outstanding commercial success and major employer is the 42-acre Liverpool ONE retail and leisure complex, which sits right in the centre of the town. This development is made up of six distinct districts, thirty individually designed buildings, 1.6 million square feet of retail space, with 165 shops, a fourteen-screen cinema, twenty-five restaurants, cafés and bars, two hotels, more than 500 apartments, 30,000 square feet of office space, a revitalised 5-acre public park, 3,000 car parking spaces, and the Paradise Street public transport interchange. It also has a weekly visitor footfall of 500,000 people!

As the foundations for Liverpool ONE were being excavated the original Old Dock was discovered in an excellent state of preservation. Today, the dock that, from 1715, began the initial rise of Liverpool to World Class status is accessible for visitors to go underground and visit. This is a powerful and moving experience, especially for Liverpudlians, who appreciate its true significance.

That Liverpool now a major, international tourist destination is perhaps the most amazing fact of the city's twenty-first-century transformation. Liverpool attracts 34.8 million tourists each year to visit and stay in one of the world's most popular cities. This generates an annual income of £2.9 billion. Liverpool is currently the fifth most popular destination in Britain for

The Echo Arena and BT Convention Centre Liverpool, now accompanied by the Exhibition Centre. (Discover Liverpool Library)

The excavated Old Dock, the source of the city's ascent to success and prosperity. (Discover Liverpool Library)

overseas visitors, and eighth most popular for domestic visitors. Hotel and apartment building continues at a remarkable pace and hotel bookings are up by 60 per cent since 2014. The city is filled with eager, happy people enjoying a traditional 'Scouse' welcome.

These people come to see so many things, not least to explore everything possible to do with The Beatles. This includes their childhood homes, their schools and college, the places they performed (especially the Cavern Club), and the pubs they drank in, among many other attractions. Liverpool's Cavern Quarter is the hub for all this celebration. In fact, the legacy of the 'greatest pop group the world has ever known' brings in around £829m each year to Liverpool's economy, and supports at least 2,300 jobs.

In effect, since the start of the millennium, Liverpool has been able to completely reinvent itself. What was once a place of poverty, slum housing and mass unemployment, is now a vibrant centre of holidays and tourism, as well as of innovation and commercial investment.

How the majority of Liverpudlians now earn their living has changed beyond all recognition from when the city was at its Victorian industrial and maritime peak. Now it is largely the tourist industry, plus the accommodation, travel and transportation, dining, sports, arts and entertainment sectors that provide a significant number of Liverpool's jobs. This is not the entire story, of course; thousands of people are still employed in the public sector, in manufacturing and production, in information technology, education, building and construction, and in private enterprise. New businesses are continually developing or are being attracted to the city. Over the next five years at least 15,000 new and sustainable jobs are expected to be created as a result.

Much still needs to be done though, to develop the economic and social wellbeing of many Liverpudlians, and there are approximately 5,500 people unemployed across Liverpool City,

Mathew Street in the Cavern Quarter. (Discover Liverpool Library)

out of a population of 466,415 (2011 census). Nevertheless, the future is brighter now than it has been for almost three generations. Liverpool's belligerent independence has seen its people defy war, economic collapse, social breakdown, and political ineptitude. The city now stands determined to continue its remarkable renaissance, and not just with its face to the world but with its arms open wide in welcome.

One of the clearest demonstrations of this, and one with a significant economic benefit, is a development that brings the city right back to its roots in international maritime commerce.

After the post-war decline of Liverpool as an international port, the city did have occasional one-off visits from cruise vessels like the *QE2*, but they had to anchor in the middle of the river and ferry people ashore by tender. Then, in 2007, Liverpool opened a cruise liner landing stage costing over £19 million.

Recreating Liverpool's glory days as an early twentieth-century transatlantic and world-wide cruise liner port, this 1,150-feet-long floating berth lies adjacent to Princes Dock. Today, the largest and most modern liners in the world are now regularly coming to the city. Very few ports in the world have liner berths directly at their heart, but Liverpool now rejoins Sydney, New York, Venice, and Barcelona as port destinations of choice. In fact, over the next few years Liverpool will see an average of between fifty and seventy-five vessels a year sailing to and from the port and this figure is set to grow. These great vessels and their passengers bring around £7 million each year into the local economy and generate hundreds of jobs.

It often surprises people to discover that the maritime industry remains a key foundation of our regional economy. In fact there are more commercial vessels using the River Mersey today than at any time in its history: it is just that the vast majority of these vessels do not sail further up-river than the north docks at Seaforth and Bootle Container Terminals. Although

Liner berthed at Liverpool's multimillion-pound cruise liner terminal. (Discover Liverpool Library)

largely automated, these facilities employ large numbers of people on site, but principally support a vast network of transportation and haulage contractors, vehicle maintenance companies, logistics and IT businesses, and many satellite and supply chain companies. This is in addition to the organisations that manufacture and maintain the hundreds of thousands of shipping containers that pass through the facility each year.

The Mersey docklands are now owned by Peel Ports, and the company handles around 40 million tonnes of cargo a year on the Mersey. According to government figures, Liverpool now stands sixth in the top ten ports for freight traffic. Indeed, Liverpool is now the main UK container port serving North America.

In 2016, and at a cost of £400 million, Peel Ports opened Liverpool's largest and newest harbour at Seaforth, named Liverpool 2. This was built to accommodate the largest container vessels in the world, known as 'post-panamax' vessels. These are so huge that they are even too broad to fit through the recently widened Panama Canal. Liverpool is now one of only a limited number of ports in the world large enough to accommodate these ships.

And so the story of Liverpool, and how it traded with the world and created work for its diverse and energetic populations, has come full circle. It began as a tiny fishing hamlet and so derived its living from the river and the sea. Its evolution over the centuries to World-Class status continued to be founded on the 'seven seas' and international trade. Over the 800 years of its existence, and despite the troughs that Liverpool suffered alongside the peaks of its great achievements, the city continues to carve out a global role for itself and its people. Liverpool has reclaimed international respect and renown.

As new developments continue, business and enterprise are creating an increasing number of jobs and career opportunities. The population numbers of Liverpool are beginning to increase again and, over the coming decades, 'Liverpool at Work' will once again be something unique and very special. Its continuing evolution and undoubted progress are breathing fresh life and energy into this 'World in One City'.

The cranes and harbour at Liverpool 2. (Discover Liverpool Library)

The heart of Liverpool's modern waterfront, symbolising the city's confident, outward-facing future. (Discover Liverpool Library)

BIBLIOGRAPHY

B ailey, F.A. and Millington, R., *The Story of Liverpool* (Liverpool: Corporation of Liverpool, 1957)

Belchem, J. (ed.), *Liverpool 800: Culture, Character and History* (Liverpool: Liverpool University Press, 2006)

Chandler, George, *Liverpool* (London: B T Batsford Ltd, 1957)

Crick, M., *The March of Militant* (London: Faber, 1986)

Evans, R., *The Merseyside Objective One Programme: Exemplar of Coherent City-Regional Planning and Governance or Cautionary Tale?* European Planning Studies, 10(4), 495–517 (Liverpool: 2002)

Frost, D., and Phillips, R. (eds), *Liverpool '81: Remembering the Toxteth Riots* (Liverpool: Liverpool University Press, 2011)

Hand, Charles, *Olde Liverpoole and Its Charter* (Liverpool: Hand & Co., 1907)

Heseltine, M., *Life in the Jungle: My Autobiography* (London: Hodder & Stoughton, 2000)

Heseltine, M., *No Stone Unturned: In Pursuit of Growth* (London: Department for Business Innovation and Skills, 2012)

Hinchliffe, J., *Maritime Mercantile City* (Liverpool: Liverpool City Council, 2003)

Howell Williams, P., *Liverpolitana* (Liverpool: Merseyside Civic Society, 1971)

Hyland, P., *The Herculaneum Pottery* (Liverpool, 2006)

Lancaster, B. H., *Liverpool and Her Potters* (Liverpool, 1936)

Lane, T., *City of the Sea* (Liverpool: Liverpool University Press, 1997)

Littlefield, D., *Liverpool One: Remaking A City Centre* (London: Wiley, 2009)

Liverpool City Council, *Liverpool Local Development Scheme: 2006* (Liverpool: Liverpool City Council, 2009)

Merseyside Socialist Research Group, *Merseyside in Crisis* (Birkenhead: Merseyside Socialist Group, 1980)

Muir, R., *A History of Liverpool* (London: Published for The University Press of Liverpool By Williams and Norgate, 1907)

Murden, J., 'City of Change and Challenge: Liverpool since 1945' in J. Belchem (ed.) *Liverpool 800* (Liverpool, 2006)

Nicholson, Susan N. (ed.), *The Changing Face of Liverpool: 1207–1727* (Liverpool: Merseyside Archaeological Society, 1981)

Paget-Tomlinson, E., *The Illustrated History of Canal and River Navigations* (Sheffield, 1993)

Parkinson, M., *Liverpool on the Brink* (Oxford: Policy Journals, 1985)

Power, M., (ed.), *Liverpool Town Books 1649–1671* (Stroud: Sutton Publishing Ltd, 1999)

Pye, K., *Liverpool: The Rise, Fall and Renaissance of a World-Class City* (Stroud: Amberley Publishing, 2014)

Thomas, H., *The Slave Trade: History of the Atlantic Slave Trade, 1440–1870* (New York: Simon & Schuster, 1997)

Various Contributors, *A Guide to Liverpool 1902* (London: Ward, Lock & Co., 1902)

ABOUT THE AUTHOR

Born and bred in Liverpool, Ken Pye retired as the Managing Director of The Knowledge Group in 2016. In a varied career spanning over forty-five years Ken has also worked in a number of professional sectors, including as Residential Child Care Officer, Youth and Community Leader, Community Development Officer for Toxteth, North-West Regional Officer for Barnardos; National Partnership Director for the Business Environment Association, and Senior Programme Director with Common Purpose. Ken continues as Managing Director of Discover Liverpool.

A keen local historian, Ken is a frequent contributor to journals, magazines and newspapers, and is the author of a number of books on the history of his home city, including *Discover Liverpool*, *The Bloody History of Liverpool* (both of which are now in their 2nd editions), *'A Brighter Hope'* (about the founding and history of Liverpool Hope University), *Merseyside Tales* and *More Merseyside Tales*, *Liverpool: The Rise, Fall and Renaissance of a World Class City*, *Liverpool Pubs*, and *A–Z of Liverpool*. He is also a popular after-dinner speaker and guest lecturer as well as a regular broadcaster for both radio and television. Ken is a previous Proprietor of the Liverpool Athenaeum, is a Fellow at Liverpool Hope University, and a Fellow of the Royal Society of Arts.

Ken is married to Jackie and they have three grown-up children; Ben, Samantha and Danny.

Visit Ken's website at www.discover-liverpool.com

Ken Pye with his family. (Discover Liverpool Library)